Presented To:

_____

From:

_____

Date:

_____

# Born to Create

# Born to Create

## Create

*Stepping into Your SUPERNATURAL Destiny*

# THERESA DEDMON

DESTINY IMAGE® PUBLISHERS, INC.
P.O. Box 310, Shippensburg, PA 17257-0310

*"Promoting Inspired Lives."*

This book and all other Destiny Image, Revival Press, MercyPlace, Fresh Bread, Destiny Image Fiction, and Treasure House books are available at Christian bookstores and distributors worldwide.

For a U.S. bookstore nearest you, call 1-800-722-6774.
For more information on foreign distributors, call 717-532-3040.
Reach us on the Internet: www.destinyimage.com.

ISBN 10: 0-7684-4143-9
ISBN 13: 978-0-7684-4143-7
Ebook 978-0-7684-8818-0

For Worldwide Distribution, Printed in the U.S.A.
6 7 8 9 10 11 / 16

# Dedication

I would like to dedicate this book to our Creator who has given us all such diversity, uniqueness, and destiny as His supernatural sons and daughters. And I would like to dedicate this book to all those who throughout history have listened to the voice of Creator and have fulfilled their unique destiny. Now it's up to us to listen and find our path.

# Acknowledgments

First of all, I want to thank my husband, Kevin, who has believed in me as a woman in ministry and has given me wings to pursue my destiny. His legacy and his heart have always been my constant joy. Thanks for believing in me even before I had truly believed in myself!

I would also like to acknowledge my children, Chad, Alexa, and my daughter-in-love, Julia, who are living out their supernatural destiny, transforming people around the world! I not only treasure who they are but the legacy they are leaving behind for others to follow.

I would also like to thank Bethel Church, especially Bill Johnson, Kris Vallotton, and Danny Silk who have taught me how to be free and explore my creative destiny. Thanks for opening me to see the fullness of what every believer can walk in and that the impossible is logical to the sanctified supernatural mind.

Words cannot express gratitude and appreciation for all of the students at Bethel School of Supernatural Ministry. I have had the

privilege to pastor and teach as well as the pastoral staff. Our journey together is what has spurred on this book and has forever been a part of my journey.

Special thanks to Allison Armerding who has helped edit my book. Your understanding of me, as well as your skills, have helped flesh out this book.

Lastly, thanks to my special friends who have been there with me through the process—Donna, Valerie, and Sheri—I love you so much!

# Endorsements

Theresa's book entitled *Born to Create* is like a prophetic manifesto inspiring another renaissance. This book awakens the childlike imagination of its readers and challenges each of us to a level of creativity that can only be described as supernatural. *Born to Create* is also a "how to" manual that will give you the tools you need to develop your God-given abilities.

Theresa Dedmon has been leading our artists and creative people for eight years. A culture has been birthed out of her ministry that is literally capturing the hearts of people from all walks of life. Some of the most amazing testimonies that I've ever heard have emerged out of this artistic community. Now Theresa has somehow managed to capture in words the ministry that she has pioneered here at Bethel Church and around the world.

Whether you're a novice or a professional artist, this book is for you. It will inspire, encourage, and equip you to new levels of creativity that you never imagined possible. May the Creator of the

Universe meet you in the pages of this book and lead you into the palace of your dreams!

Kris Vallotton
Co-founder of Bethel School of Supernatural Ministry
Author of seven books, including
*The Supernatural Ways of Royalty*
Senior Associate Leader of Bethel Church
Redding, CA

You don't really determine your destiny; you discover it! *Born to Create* by Theresa Dedmon is possibly one of the greatest tools to help the Church fill the earth with the Glory of God. This book is a must-read for everyone who wants to move from measure to fullness. There is potential, untapped power, unused success, undiscovered wealth, and a world-changer within you that will be released through *Born to Create*.

God says, *"For I know the thoughts that I think toward you, says the Lord, thoughts of peace and not of evil, to give you a future and a hope"* (Jer. 29:11). Don't waste God's gift in you.

After reading this book, I no longer have any excuse to not be and do everything that Papa-God has for me. Warning! The world will never be the same!

Leif Hetland
President, Global Mission Awareness
Author of *Seeing Through Heaven's Eyes*

Theresa Dedmon's zeal for life, love for adventure, and passion for God come through this book as she weaves encouragement and hope with your dreams. If you need a fresh wind in your creative sails, *Born to Create* will do it. As a creative leader in our Bethel

environment, Theresa has inspired young and old to trust God to work through their creative gifts. This book is certain to release new prophetic energy into your creative gifts.

Danny Silk
Author of *Culture of Honor* and
*Loving Our Kids on Purpose*
Senior Leadership Team, Bethel Church
Redding, CA

Theresa Dedmon carries a beautiful mother-heart and draws out the dreams and creative potential in others. She loves well and shows us how creativity can be used powerfully to demonstrate love in action. This book will inspire you to intimately partner with the Holy Spirit to bring transformation to every realm of society you are called to influence. The amazing testimonies in *Born to Create* will encourage you to become more childlike and believe that nothing is impossible for those who truly know that they are the Father's delight!

I pray that as you read this book, you will discover the fullness of your own creative destiny in God and express His very heartbeat to the world around you.

Heidi Baker PhD
Founding Director, Iris Global

I have known Theresa Dedmon as one of the true activators of creativity in the kingdom. She not only is an artist, imagineering creative projects of her own; she also knows how to release creativity in others. She has language and passion to increase your understanding of how God the Creator wants thrive in you. When you combine this subject matter with Theresa's gift of teaching and enthusiasm for life, you find yourself reading an explosive book that will awaken

you to new depths. She has helped me and I know she will help you as well as you are mentored by this wonderful book.

Shawn Bolz
Expression58
Www.expression58.org

This book will expand your expectations for what God can and will do through your creativity! Theresa Dedmon is a true leader in an emerging movement that's releasing supernatural creativity in Christians and churches. She loves to help draw out the destiny of God's children. I felt the Holy Spirit stirring my heart as I read her many exciting examples of how God is creatively moving at Bethel and around the world. Theresa's enthusiastic encouragement will inspire you to dream and collaborate with God to reach for your creative destiny in Christ!

J. Scott McElroy
Author, *Finding Divine Inspiration:*
*Working with the Holy Spirit in Your Creativity,*
Founder, New Renaissance Arts Movement(TheNewR.org)

# Epigraph

*"We do not grow into creativity,*
*we grow out of it."*

SIR KEN ROBINSON

*http://www.ted.com/talk/ken_robinson_say_schools_kill_creativity.html*

# Table of Contents

The culture of Heaven is one of great honor. In it we celebrate who a person is without stumbling over who he or she is not. In the atmosphere created by that culture, people become free. And it's normal for free people to dream. Freedom always creates dreamers. And dreamers impact the world with a more complete expression of God's person and nature. The time has come for this expression to become a way of life in the Kingdom.

Dreaming is a unique expression of the heart. It shows that we're alive—truly alive. Children, who typically live without cares, dream easily. And they never dream of being insignificant.

I once read that every five-year-old is an artist. I believe that is true. Tragically, the bent to create gets weeded out by educational systems that applaud only certain kinds of art, while redirecting children away from their creative expressions into cognitive skills only. They then get buttonholed into occupations like law, accounting, engineering, or other similar jobs. Each of those skills is

wonderful in its own right, but they are not known as occupations of great creativity. It was never meant to be either/or when it comes to developing the artist within versus our intellectual potential. The truth is that any skill would be enhanced beautifully by the creative expressions that should be the norm, especially for those who are born again. We are sons and daughters of the Creator. We have an edge; that should be part of our witness. But latent gifts have no effect.

*Born to Create* will no doubt have instant appeal to artists and the like—as it should. But that saddens me a bit because it's a book about freedom more than it is about the traditional subject of art. It should be read, perhaps *especially* read, by people who don't consider themselves to be creative. It just might restore the journey each person started on as a child.

Some of the greatest exploits happening in the Church right now are not coming from traditional ministry platforms, as important as those are. They are coming from people who love to dream and pursue God in the context of their unusual giftings. So instead of church leaders continually trying to fit round pegs into square holes, they are helping people become free to see how God would use them in their particular place in society. Such freedom is wonderful and contagious. This emphasis is especially conducive to art and entrepreneurship.

Theresa Dedmon has championed this cause powerfully with great success. A lover of God and a lover of people, she uses her skills to reveal the beauty of God to others. Her whole family has a most amazing gift in evangelism. People constantly come to faith in Christ through them. But what surprises me is to see the means God uses to communicate His love through Theresa—art. Theresa's effect on the non-creative types is equally astonishing. Because of it, I celebrate all the more the culture of honor that brings such freedom. For in the context of such freedom, dreamers are raised up. And

those dreamers are not afraid to believe they can shape the course of world history through the gifts given to them. *Born to Create* is a great book. A really great book!

<div align="right">

Bill Johnson
Author of many books, including
*When Heaven Invades Earth* and *Dreaming with God*
Senior Leader, Bethel Church,
Redding, CA

</div>

# *Introduction*

Embracing our creative design, which originated in the heart of our Creator, gives us the freedom to supernaturally use that creativity to transform the lives of those around us. This simple truth has radically changed my life and the way I view ministry and cultural transformation. As I travel the world, I see so many people set free to walk in their destinies and live supernaturally as they apply this simple biblical truth to their lives. I have many testimonies to share with you about people who never thought they were creative, but who are now able to tap into the Holy Spirit's supernatural power and release healing and prophetic ministry through what they create.

As this truth of our divinely designed creativity is restored, many who were born to be innovative and creative in business, government, education, arts and media, church, and family realms will find their spirits awakened to the supernatural power waiting to be discovered inside them. Those who have mastered a craft or creative expression that is influencing life in the Church or in the marketplace will discover how their excellence, when married to

the supernatural leading of the Holy Spirit, can even offer a higher benefit and purpose.

As their people are liberated to create, churches around the globe are becoming alive through transformed worship services, church ministries, and outreach in the marketplace. I am seeing people of all nations hear God speak to them in their own cultural language through the vehicle of the redeemed arts. This is similar to what happened on the day of Pentecost, when pilgrims in Jerusalem heard God speaking to them in their own languages through the gift of tongues. We are about to see a shift in how we spread the Good News because we have learned to partner with the Holy Spirit through creative cultural languages! So how do we get there?

## Resources

This book contains a gold mine of the treasures I have studied and applied in my ministry both inside and outside the Church. I want to encourage you to take advantage of all these treasures so your creativity in the supernatural can become part of your lifestyle.

At the end of each chapter, you will find exercises that will help you to apply the truths I will share with you. I recommend that you do these exercises before moving on to the next chapter. I guarantee that you will get so much more out of this book if you choose to do this.

At the end of the book, I also provide various templates designed to awaken your creativity. There is a chart with the prophetic meaning of colors so that you can learn to prophesy through colors in what you create. I have also given you a Prophetic Art Treasure Hunt Guide so that you can find treasures in people you meet (also see recommended reading: *The Ultimate Treasure Hunt*). There are creative exercises for both small groups and children to grow in the supernatural. Please freely use and adapt any and all of these resources for your ministry!

# Finding Our Way Back to the Wardrobe

E very month, the city of Redding, California, where I live, has an "Art Hop" night in our community where the public can meet local artists who are displaying their work in local businesses. I was a featured artist for one of these events and showed my paintings at a doctor's office in town. I painted a particular set of paintings specifically for this event, and beforehand, as I usually do when I paint, I soaked in God's presence and asked for a supernatural anointing to be released through my paintbrush. Since I was painting pictures for a doctor's office, I asked for an anointing that would heal those who entered the office and looked at my paintings.

On the Art Hop night, a family arrived at the doctor's office, and we began making small talk. Suddenly, the mother, Wendy Tang, became transfixed by one of my paintings and, after a moment, abruptly left the room. When she returned, she approached me and asked about buying the painting. I explained to her that I was releasing healing when I painted it and had named it, "Poppies of Delight." I then began to prophesy that the poppies represented

her children and her legacy. Wendy excitedly replied that God had given her that very message when she saw the painting!

Wendy proceeded to tell me that the painting looked exactly like a scene in a movie she had been watching on a very significant night over a year earlier. On that night, while cooking dinner for her family, she had an encounter with Jesus in which He revealed Himself to her as her best friend. Through childlike faith, she had entered into a long-awaited depth of intimacy in her relationship with God. However, that same day was also a day of grief, for it was the very day she suffered another miscarriage—her fourth miscarriage in 18 months.

When she saw the art piece "Poppies of Delight" at the Art Hop, God began to speak to Wendy about that day over a year prior. Here is her account:

> God showed me that He could not stand that there had been confusion and hurt surrounding the day that He showed Himself to me as my best friend. He had to have that moment redeemed! He had to undo the lies and confusion that the enemy was speaking over that time in my life. He was so determined that He had you paint a picture for me! Then He spoke healing love over me, brought the fullness of restoration from Heaven, wrapped me in His arms, and undid it all. Now I have this huge love letter to hang in my house and remind me that He is truly *my* best friend.

After she shared all this with me, I prayed for Wendy. One year later, God indeed added another poppy of delight and blessed her family with a healthy baby girl!

God restored Wendy spiritually, emotionally, and physically through a painting—not one hanging in church, but in a doctor's office. Supernatural creativity has the power to breathe life into seemingly hopeless situations. We just have to trust with childlike faith

that God has designed us to release this hope through what we have been given.

## A Childlike Spirit

There is a fresh wind coming for all believers who want to enter into the fullness of their identity and calling as true sons and daughters of the King of kings. This wind will awaken a childlike spirit within us so that mysteries become irresistibly attractive and what is impossible becomes logical. It will remind us that God is known for showing up in unexpected places and moving in unexpected ways, and it will train us to expect Him to do so through, in, and around us.

> God is known for showing up in unexpected palces... the impossible becomes logical.

Jesus had a lot to say about becoming childlike. When Nicodemus, a learned Pharisee, came to Jesus asking to know the power behind Jesus' ministry, Jesus told him the true way into spiritual matters was to become childlike, born of the Spirit (see John 3:1-21). In Matthew 18, the disciples asked Jesus who was the greatest in the Kingdom of Heaven. Jesus called a young child forward, telling them that unless they *changed* and became like little children, they would never enter the Kingdom (see Matt. 18:1-3). He went on to say that if you welcome a little child in His name, you welcome Jesus; on the other hand, if you cause a little one of His to stumble, it would be better for you to drown in the ocean with a weight tied around your neck! Again, in Mark 10, people were bringing children to Jesus so that He could bless them, but the disciples were getting

ticked off—as if this wasn't valuable or important to the Savior of the world. Jesus rebuked them and said that unless a person receives the Kingdom as a child, he cannot enter into it.

According to Christ, the pathway to revelation, the heart of revival, and the fullness of the Kingdom of God is *becoming child-like*. Becoming dependent as children in our relationship with our heavenly Father forces us to lose our religious mindsets and protocol. Staying in a place of wonder and trust will keep us from becoming easily offended by the ways God chooses to manifest Himself in our lives.

In C.S. Lewis's children's classic, *The Lion, the Witch, and the Wardrobe*, Lucy, the youngest of four brothers and sisters, finds a way into Narnia, another world, through the back of a wardrobe full of coats. When she makes this discovery, she ecstatically tells her siblings. Her older brothers and sister refuse to believe in this world because, from their experience and schooling, it is nonsensical and impossible. When they talk with the wise professor about Lucy's adamant rebuttal and assured belief that Narnia does *indeed exist*, he exposes their error in assessing their sister's story. He says, "There are only three possibilities. Either your sister is telling lies, she is mad, or she is telling the truth."[1] He then asks about her character and if she is known for telling the truth. They respond that she has always been honest.

The Kingdom of God has to be found in the same way Lucy discovered Narnia—through a childlike perspective. Only this perspective prepares us for a relationship built upon real encounters that go beyond human logic or understanding. It is a walk of childlike faith. Isaiah 11 talks about the power of God restoring harmony between people, animals, and the earth. At the center of this restoration is a child: *"...and a little child shall lead them"* (Isa. 11:6). Only a child can lead us into the reality where a lamb lies down with a lion because a child is not limited to a reality based on the past.

Most of us have a hard time envisioning that promised restoration simply because we have never experienced it that way!

As we pass through the wardrobe of finite possibilities and enter into God's creativity, we enter into another realm of supernatural creative power where His presence illuminates His promises. We will find the greater works Jesus promised waiting for us on the other side of the wardrobe (see John 14:12). We will discover incredible truths buried deep in His nature that He is waiting to reveal to those who believe and become childlike. This is where the journey starts. As you read this book, you must come to terms with the fact that God is greater than your limited experience. As we trust in Him like children, our trust pulls us into other dimensions of eternal truth that have always existed, but that we may never have discovered. Children find things that adults pass by because they haven't lost their sense of wonder or adventure. It's time we find our way into the wardrobe and look for the other side.

> **Children find things that adults pass by because they haven't lost their sense of wonder or adventure.**

## Discovering More

One of my greatest desires in life is to know God—not just to hear about who He is, but also to encounter Him personally. This has been the greatest adventure of my life! I am convinced that every part of this life has hidden clues that reveal His presence—if we will seek them out.

How do we find *more* in God? All of us who are believers have at times felt in awe of God, whether in worship or when He came

upon us in a powerful way, as Wendy Tang experienced. When we encounter God, He deposits seeds of revelation that will lead us into a fuller understanding of who we are and who He is. Colossians declares that we are created for Him and held together by His power:

> *He is the image of the invisible God, the firstborn over all creation. For by Him all things were created: things in heaven and on earth, visible and invisible, whether thrones or powers or rulers or authorities; all things were created by Him and for Him. He is before all things, and in Him all things hold together* (Colossians 1:15-17 NIV).

He is the One who has created the visible and invisible realms. There is so much more to His nature than we realize. And when we enter into relationship with the One who made us and who holds everything together, we enter into the purposes for which He created us. When we understand who He is, then we can comprehend who we are, for we carry *"Christ in* [us], *the hope of glory"* (Col. 1:27). What we *do* with this revelation will determine our future.

When a child is welcomed into a family, the parents are the first to examine the baby, making sure that everything is touched, loved, and functioning. The first moments of smiles, tears, and joy are captured through photographs. In the same way, God wants us to understand His nature through the first words He spoke to us, His beloved children. In Genesis 1, God made Himself known as the Creator: *"In the beginning God created..."* (Gen. 1:1). Light, life, and matter were formed from His being and spoken word. The Hebrew word for "create" is *bara*.[2] This means "to form from nothing," as God did in creating the world. It also means "to reform from existing materials," which is how God created Adam (from the dust of the earth) and Eve (from the rib of Adam). God had a unique plan and design, which took form when He spoke and when He breathed life into humanity. And everything He created wasn't just "good," but full, rich creative outflow. The Hebrew word for "good" in Gen-

esis 1 is *towb,* denoting beautiful, prosperous, morally good, delightful, flourishing, profitable, and much more.[3] God didn't just hit the ball out of the park; He hit it out of the universe. Creation is beyond anything we could have ever imagined.

The characteristics of God's creative nature can be found in His creation, both unseen and seen. First of all, God's creativity has no end and no beginning. It is forever moving, taking shape, and bringing redemption. He didn't create the universe and then stop creating. The power of what He created continues to flow and emerge in all that is. His creativity holds the world and us together, as Colossians points out. Not only is God's creativity *always* good; it is supernatural and is constantly working out a supernatural plan for us that is much grander than human reason and natural imagination. Scientists are still discovering the detailed and minute intricacies in creation and the human body.

His words generate life and bring healing and restoration in a spiritual, relational, and physical way. His creativity and love are not bound by time or the constraints of earthly laws, which means they can transform any situation governed by natural laws. When God introduced Himself as Creator, He was letting all of His children know that He is the originator of everything and that whatever He created is good and will continue to bear fruit. Creation also reflects His creative nature in that every element is related to, supports, and depends upon all the others, just as the many attributes and facets of His character are all related to each other.

The next significant revelation in the creation story is that God made humanity in His image. This means we have the power to create like our Father because we are His sons and daughters! His whole redemptive plan was to restore us back to right relationship with the Godhead so that we could enter into partnership with Him and represent Him to the world. We are involved in the family business. This means that our creative power, linked to our relationship

with the Father, will release His creative power to transform the world around us. Our mandate is to be so in tune with the Father's heart that we bring His creative flow to earth. What if we discovered His creative thoughts of restoration for this planet, for us, or for all of humankind? His plans, dreams, and desires for cultural and personal transformation are only a thought away and can be accessed through declarative words filled with wonder and power.

What if we could glimpse how He is creating now? What if we could glimpse the expansiveness of His Kingdom coming to earth? Would we want to discover beyond what we already know about Him and fall helplessly in love with the One who really has endless surprises waiting for us to discover? Even more surprising is that He chooses to partner with us for transformation! He wants us to discover, through childlike faith, the wardrobe door into His world of creativity and goodness.

## My Journey

Let me tell you a little bit about my journey before we go further. I never thought my imagination and creativity were valuable to God because I thought I was made to work *for* God's love, not *from* God's love. In other words, I thought He was interested in what I could *do* for Him, but not in who I was. I was striving to be a daughter, never knowing that I already was one. I had been indoctrinated to believe that I had to earn God's favor by what I could produce. I couldn't break free from the idea that my worth came from my service for Him—I thought that was all He cared about!

> **I thought I was made to work for God's love, not from God's love.**

When I came to Bethel Church in Redding, California, in 2002, I began to comprehend His value for me as a person, not as a slave doing a master's bidding. In studying the creation account, we see that God didn't make man and woman in His image and then tell them they had to do this or that to keep His love. No, He would be with them, even when they disobeyed Him. He was their Maker and would always be their Father. This truth had been hidden from me because I wasn't coming like a trusting child, but as an insecure orphan. As I sat underneath the leadership team at Bethel Church, who understood God's unconditional love, I realized that if it mattered to me, as Bill Johnson said, then it mattered to God. I wasn't stuck with a grueling taskmaster; I was reborn into a family with a loving Father who cared about me as His precious daughter! These truths radically changed the way I saw God and the way I saw myself.

I discovered that I was actually part of the greatest love story of all time and that I was the object of God's love! It began to dawn on me that I had limited God by believing His mercy and grace only went so far. I thought I could never measure up to God's standards for me. I was caught in a religious mindset, where grace saved, but could not keep—where God's love went only as far as He deemed valuable.

In the midst of this, grace apprehended me! I learned that God is not out to get me. He is not out to make me suffer or to prove that I am a failure. He came to earth to lavish His love on me! I began to identify my future with First Corinthians 2:9: *"Eye has not seen, nor ear heard, nor have entered into the heart of man the things which God has prepared for those who love Him."* I knew in my gut that His unconditional love was real and that He had been waiting to bless me all my life with a limitless love!

His love is not only powerful and unconditional, but it is *creative in nature!* His love is creating good things for you to find right now as you read this. If you, as I did, have never felt accepted as a son or

daughter, now is your time to walk through the wardrobe door and let God love you. This will be the most freeing experience you will ever have. God loves you just the way you are. Let God's unconditional love create life inside you right now!

## We Have the Mind of Christ

When we read First Corinthians 2:9, many of us stop at this verse, concluding that what He has prepared for us goes way beyond our reach or comprehension. But when we do, we give up on what is already rightfully ours. Verse 10 continues, *"But God has revealed them to us through His Spirit…"* In other words, we don't have a clue how good God is unless we ask for a revelation from His Spirit, but we are assured that it is *available* for the taking. It's waiting for us to discover!

Furthermore, Jesus gives us a clue as to what God has prepared for us: *"He who believes in Me, the works that I do he will do also; and **greater works** than these he will do, because I go to My Father"* (John 14:12). Why would He say that unless there was more for us as believers? We follow His legacy, which only started with His healing and miracle ministry on earth. I have tried walking on water in my bathtub. Though I haven't yet gotten a toe to float, it doesn't mean it is not possible—it only means I haven't experienced it yet.

What bothers me isn't just that we fall short of what Christ did do, but that we don't go after more. What did He mean by greater works? Where do our imaginations go in this great playing field of possibilities? What stops us? Why is creativity so frightening to us? It's like there is an imaginary electrical fence marking how far we can go in our imaginations, and if we go too far, we fear we will be zapped into crispy critters. It's as if there are signs on the wardrobe saying "Danger Ahead"—but we don't have the courage to find out who put them up!

I know that all of us are in awe of God and of what He has created, but there is so much more beyond the veil of what has been already created. Jesus invites us to the journey of discovering what more is available to us while we are alive on earth. God has designed the natural world to reflect greater realities. These realities exist in spiritual seed form, which we tap into through the Holy Spirit. The creative nature of God's design really knows no limits. It is not only legal to pursue, but it should be our playing ground. His love and creativity are greater than we think!

We have to go over to the other side of the fence and see what God has in store for us and begin to partner with Him to bring a greater reality into our world. I believe that the thought of believers who understand God's creativity is something that terrifies the enemy, who cannot create—he can only copy and distort. The saints, understanding of the creative power and plan of God has more power to transform than all the enemy has tried to do in the past. We need to see that:

> ...*the weapons of our warfare are not carnal but mighty in God for pulling down strongholds, casting down arguments and every high thing that exalts itself against the knowledge of God*... (2 Corinthians 10:4-5).

Paul was not referring to a physical reality, but to the real war that wages in our imaginations over our power to comprehend the greater realities of the knowledge of God. Winning this war starts with us believing that we were born for greater works and that our imaginations are the seedbed for them to take form. Our imaginations are where we begin to see impossibilities materialize.

> **Our imaginations are where we begin to see impossibilities materialize.**

I am tired of the Body of Christ believing in a God who doesn't plan for His kids' futures! God gets excited at the prospect of creating greater realities than past generations have seen. Just study Hebrews 11:39-40:

> *These* [great women and men of faith mentioned in Hebrews 11] *were all commended for their faith, yet none of them received what had been promised. God had planned something better for us so that only together with us would they be made perfect* (NIV).

All of our great ancestors in the faith are waiting *for us* to run our race, and they won't get their full reward until we all complete our mission on earth. God wants us to go even farther than they did because we have their example and are called to use their ceiling as our floor! I want my kids to have greater influence and favor than I do, and I know that thought comes from my heavenly Father!

There is something inside of me that is deliciously curious and excited. I want to understand the greater realities of a Creator who is creating things for me right now because He loves me. I don't want to focus on what I don't have or dwell on my past shortcomings until I think I'm holy enough—a lie the enemy loves to trap us in.

Why is it so difficult to trust and come to God as a child and ask for more? Do we have a stronghold of fear and don't want to rock the boat? Do we struggle with a false humility that says, "Well, who am I to ask for so much?" Both reasons are sad commentaries on God's goodness. What if Esther had asked that only she be saved because she thought it was too much to ask to save all the Jews? What if the disciples had said, "Only Jerusalem needs to be transformed"?

You and I were brought into the Kingdom of God because people were willing to ask for more. If we feel we are inadequate or unworthy and, therefore, settle for what others have already secured and never ask for more, we forfeit our birthright and inheritance, and we

prevent generations from benefiting from what we could have given them. I wonder what would happen if we really saw more in our imaginations and knew what God has in store for us. Like Moses before the burning bush, we need to see how the great I Am sees us and not disqualify ourselves just because we stutter. I think that if we took that risk, we would find so much life on the other side that we would have the courage to cut down the electric fence and let others follow us in. We would find out why we were born. Fences made out of fear keep us bound from exploring our God-given paths. God wants us to get out the cutters and slice through the fences that have keep us from our destinies.

I have to pursue who He is beyond what I currently know or have experienced. I have to believe it is possible, and then I have to make sure that I am drawing that world and truth into the way I live. Yesterday's manna cannot be the breakfast of today's revivalists any longer. Let's follow the lead of Paul, who knew there was more and was willing to let go of past limitations and experiences to go for it:

> *Not that I have already obtained all this, or have already been made perfect, but I press on to take hold of that for which Christ Jesus took hold of me. Brothers, I do not consider myself yet to have taken hold of it. But one thing I do: Forgetting what is behind and straining toward what is ahead, I press on toward the goal to win the prize for which God has called me heavenward in Christ Jesus* (Philippians 3:12-14 NIV).

## Jessica's Story

I met Jessica at a church in Southern California. I was training this church to reach out to people in their community through different creative expressions. I train people to prophesy and call out the gold in people through every way imaginable because it's legal to be creative in the Kingdom of God! One of these creative expres-

sions is balloons—that's right, balloons! I train people to prophesy with balloon crowns and to knight men with balloon swords. It is such a powerful medium! Some of you may be laughing and thinking to yourself that you would never do this, but wait until you hear what happened through one balloon crown!

On our outreach, 14-year-old Jessica saw a homeless woman sitting in a park. She grabbed a balloon crown and went over to her. They began to talk, and Jessica found out the woman had been homeless for over 15 years. Jessica crowned the woman as a royal princess, declaring that God would find her a home and a place to live because she was His daughter. Jessica then joined her team in another area of the park for a couple hours and ministered to many people in the city.

Jessica wanted to check in with the homeless woman on the way back to the church to see how she was doing. When they saw each other, the woman's face lit up. She told Jessica that a couple minutes after their conversation, a woman who had visited her previously had come up and offered her a place to stay for three years. The homeless woman had been crowned a daughter, and the King of kings had found her a palace! God's creative supernatural power was released through childlike faith in Jessica, bringing God's Kingdom down into this woman's life.

What we declare through partnership with His goodness transforms lives! So, I guess the question we all have to ask ourselves is this: What do we really believe about His love for us? Are we a people who will settle for what has already been revealed about His goodness, or will we follow Lucy and Jessica into the wardrobe through childlike faith and curiosity? God desires to open us up to limitless creative potential. How far have our imaginations really gone in knowing His love for us as well as others?

# Think Outside the Box Exer

Many of us need to get out of the ruts of "norma
we have "always been." We settle for what we thi
in family, culture, or church life. This creates a ser
many times can deter us from thinking creatively and innovatively.

This reminds me of a story about a grandma and her roast. One
day a young daughter was watching her mother make a roast for
the family. She watched as her mother cut off the two ends of the
roast and put it in the pan, along with the potatoes and vegetables.
Perplexed by the procedure, the child asked why her mother cut off
both ends. The mother smiled and answered, "Because that's the
way grandma always did it." The next time the child saw her grand-
ma, she asked her why she did this. Her grandma answered that she
had cut off the ends of her roasts and baked them in a small pan
because the stove she had was so small.

Like the girl's mother, many of us do things a certain way be-
cause that's the way they have always been done, and we never find
out if those things are still relevant today. So let's take a moment and
think outside the box of what has been done in the past, asking God
to reveal Himself to us afresh.

# Imagination Exercise

*Take a moment, and imagine that you see yourself from your Cre-
ator's viewpoint. He made you in His image, and He gave you His
likeness. You are free to be His child and to come to Him. You are free
to play and just be you!*

*Are you ready to take God's hand and enter the wardrobe? If so, go
ahead and let your imagination take you inside the wardrobe. Write*

*n what He shows you! What is on the other side of the more He
has for you?*

---
---
---

I shared my personal breakthrough in discovering God's uncon-
ditional love and grace for me. Do you know you are accepted and
loved just the way you are and that you can't earn it? Take a moment
and ask God to show you through your imagination what He has
planned for you—what His desire is for you. Read First Corinthians
2:9-10 to give you a glimpse. **Make sure** that you don't limit it by
what you have **already** experienced. Ask what is available through
His love for you now!

---
---
---

Part of the process of creative imagineering is declaring who we are
in light of who God says we are, like the homeless woman who found a
home through the declaration and creativity released through a balloon
crown. Let God crown or knight you. See Him pronounce you are His
son or daughter!

---
---
---

*Now, take some time and start to declare who you are!*

*I am* _____.

*I carry* _____.

*God declares I am* _____.

# Endnotes

1. C.S. Lewis, *The Lion, the Witch, and the Wardrobe* (New York: Macmillan Publishing Company, 1950; First Collier Book, 1970), 45. Citations are to the First Collier edition.

2. *Strong's Exhaustive Concordance of the Bible,* s.v. "Bara," Hebrew #1343.

3. *Strong's Exhaustive Concordance of the Bible,* s.v. "Towb," Hebrew #2896.

# Taking Back Your Imagination

I remember the day as if it were yesterday. It was my first Sunday at Bethel Church in Redding, California, and I was very interested to hear senior pastor Bill Johnson speak. As he began, I had an open vision. I saw myself painting in the back of the sanctuary as he was preaching. I thought this was strange, as I had not painted seriously since I was a teenager. Although my mother was an artist, and I had accomplished many creative endeavors in visual and performing arts, I had never seen how painting could be relevant to a church service, let alone to my personal destiny. I didn't think much about it at the time and merely dismissed it—until I attended the night service, where I saw someone painting on stage next to the worship team. Still, the concept was so foreign to me that I kept this vision to myself. I really didn't get it until a year later, when Kris Vallotton, overseer of Bethel School of Supernatural Ministry, asked me to teach prophetic arts in the school.

I realized then that I had subconsciously believed the arts took a back seat to what was truly valuable, like preaching—hence my

vision of being relegated to the back of the church as I created and feeling so out of place when painting while Bill was speaking. I felt I was drawing people's attention away from what should be center stage. Now I understand how creative expressions can not only enhance the Kingdom message, but also can embody it. They not only deserve a platform, but they also have relevance for others who need to understand who God is through a different creative expression. A prophetic painting can be worth a thousand sermons.

> **Creative expressions can not only enhance the Kingdom message but can emody it.**

Transformation happens in our imaginations, whether or not we "get it" at the time. My imagination painted a vision of what my life was like through my restricted religious lens. I needed an adjustment to embrace my full destiny. God knew I couldn't receive it in word form, so He gave me a picture that could not be forgotten. God used my imagination to awaken me to the role of creativity in communicating and receiving the Kingdom of God. This is part of the message I take around the world to all types of people and nations.

As I release people into supernatural creativity, I am amazed at how many people have not seen their imaginations as vehicles for transformation. As I equip them, they spiritually wake up as they see how what they create can prophesy and bring hope and healing to others. Many people end up crying tears of joy because they had no idea how easy and simple it is to share Christ's love as they partner their sanctified imaginations with the Spirit of God.

# Imagination Block

It is time to awaken our spirits to the reality that the good news of the Kingdom of God is waiting to be released through our imaginations as the Holy Spirit leads us. We have to ask ourselves why we have been so reticent to use our imaginations. I believe one of the reasons is that we have been trained not to trust ourselves and have subconsciously thought the imagination is scary or evil. Sometimes we can ignore the fact that we even *have* imaginations. And if we do have creative thoughts, we often make sure they mirror what is popular or safe so we don't "rock the boat." All you have to do is look in most Christian bookstores and see the art on the walls to comprehend the level of excellence and originality most people view as normal for Christians to purchase. For the most part, the only acceptable pictures are conservative landscapes or pictures of Jesus with a halo around His head, looking stoic and otherworldly.

It grieves me that we can be intimately acquainted with the Creator of the universe and yet not be able to translate this into cultural artifacts. Is the Jesus we see portrayed in popular Christian media, entertainment, and visual artistic expression really the God we know in the Bible and personally? Do people in society see Him represented as powerful, mysterious, joyful, and relevant? Is the work so outdated and marginalized that they don't see Him at all? Something has to change, and it isn't Him—it's us! Let's begin to experiment with ways we can use our imaginations to build bridges to the hearts of others so that the real Jesus can be seen.

I am not saying that we have made no headway in stepping up the standard of relevant music, arts, and media. I believe we are stepping into being presence-based as we create with a spirit of excellence, but this will only happen as we trust our imaginations. Albert Einstein, one of the great geniuses of our time, said, "Imagination is more important than knowledge."[1]

Let's become the forerunners of music, arts, and entertainment that draw people into His presence. There is already a growing movement—through social networking connections like Facebook, YouTube, and Twitter—of people who are writing, drawing, creating, and bringing their imaginations into the equation of who they are! Many believers are linking in with Holy Spirit and their unique creativity by making blogs, songs, and YouTube videos. We are living in exciting times when we can touch millions of people artistically through the many ways we can communicate.

Creativity will always be on the forefront of what influences culture. So let's be on the cutting edge, like Aimee Semple McPherson, who began the first Christian radio program and touched so many by imagining ways to utilize the new technology of her day.

We need the whole Body of Christ to realize the potential lying dormant in the imagination. Many of us have gone through life thinking that using our imaginations is not godly or necessary. We know what we shouldn't fill it with, but we have no idea what could take the place of the bad. To a great degree, we have thrown the baby out with the bath water. The Bible says to fill our minds with *"whatever is true, whatever is noble, whatever is right, whatever is pure, whatever is lovely, whatever is admirable…excellent or praiseworthy…"* (Phil. 4:8 NIV). Let's bring excellence back into the playing field of what we create and how we transform society. Everybody loves truth, beauty, and excellence because these are attributes of the Creator. Let's give people something they can't take their eyes from. Let's create imaginative books that will become best sellers, ones that people will have to read over and over again because the characters are so vivid. Let's give people a reason to know the Creator of the Universe.

I believe another reason we have lost the art of imagining is that we have relied on others to tell us what to think. If you go

to the bookstore or turn on the television, those who are trying to convince people to try this or to try that so they can improve the quality of their lives will bombard you. We Christians aren't much different. Many believers' libraries are lined with self-help or improvement books. Like the world, we think that if we just find out what this person knows and do it, we will lose weight, be better Christians, have better marriages, and live better lives. In this society, we want other people to do our thinking for us. We can Google anything we want because the research has already been done. We haven't learned that we can take this information and use our imaginations to extract the best revelation! God gave each of us our unique imaginations, something no one else has. It's time for us to begin to release it as we follow the Holy Spirit and touch others.

## The Legacy of King David's Imagination

The life of King David provides a great example of using the imagination to transform the world. David's life was not easy. He was mocked and dismissed by his brothers when he wanted to slay Goliath. His own father didn't even recognize him as a son worthy of the prophet Samuel's anointing. His father also relegated him to tend the sheep. But when he was alone, he wrote songs recording his struggles and victories. In the Book of Psalms, we find out how much he learned to rely upon God in the midst of every trial he faced. The magnitude of his legacy still continues to impact us as believers. Psalms is the largest and perhaps most widely used book in the Bible. Its poetic, imaginative wording sheds light on the magnificence of God and how He will always be with us. It explores the full range of human experiences in a very personal and practical way, covering diverse topics such as joyful celebration, war, peace, worship, judgment, messianic prophecy, praise, and lamentation. Aren't you glad David used his imagination and taught other psalmists to do the same?

We were made with imaginations that reflect the heart of Creator God, who imagined you and me into being! The more we release our imaginations to dream and visualize from Heaven's perspective, the more God can create things through us to fulfill His purposes! Let's find out how we can carry His presence through creativity that not only brings glory to the Creator, but also shows the many facets of His being. He is wild, mysterious, playful, and abundant in mercy; He shows up in the dirtiest places on earth, and He likes to laugh!

**Releasing our creativity, shows the may facets of His being.**

## Seeds of Imagination Are Fertilized Through Desire

The first step in this process is to bless your imagination and realize that it carries the seedbed for dreams, destiny, and desires from the Creator. We need to understand how our imaginations release our desires and thus lead us to fulfill our destinies. Actor and comedian Jim Carrey actively used his imagination to reach for his desired acting career:

> When I wasn't doing anything in this town, I'd go up every night, sit on Mulholland Drive, look out at the city, stretch out my arms, and say, "Everyone wants to work with me. I'm a really good actor. I have all kinds of great movie offers." I'd just repeat these things over and over, literally convincing myself that I had a couple of movies lined up. I'd drive down that hill, ready to take the world

on, going, "Movie offers are out there for me, I just don't hear them yet."

In 1990, while sitting there looking at the city below and dreaming of his future, Carrey wrote himself a check for $10 million, dated it Thanksgiving 1995, added the notation "for acting services rendered," and carried it in his wallet from that day forth. The rest, as they say, is history. Carrey's optimism and tenacity eventually paid off, and by 1995, after the huge box office success of *Ace Ventura: Pet Detective, The Mask,* and *Dumb & Dumber,* his asking price had risen to $20 million per picture. When Carrey's father died in 1994, he placed the $10 million check into his father's coffin as a tribute to the man who had both started and nurtured his dreams of being a star.[2]

What do you think can happen when the sons and daughters of God use their imaginations to envision and declare the dreams their heavenly Father has put in their hearts? The Holy Spirit wants to blow fresh wind on our desires, awaken our imaginations, and expand our vision of what is possible as we partner with Him for transformation. Your Father wants us to be His stars, shining in the darkness of this world. He wants us to ask so we can receive! If we are sons and daughters of the Most High God and are His royal priesthood, what kind of imaginative thoughts and desires need to be rummaging about in regards to God's plans for us? What kinds of "withdrawals" do we need to begin making from our royal family storehouses in order to bring Heaven's restoration to the world around us? Our faith materializes through our imagination and takes shape through our declaration.

### *Dream a Little Dream...*

Why are our dreams so powerful? Joseph had a dream about his brothers and parents bowing down to him (see Gen. 37). Now, I know that if one of my children had this dream, no matter how

much I loved him or her, I would deduce that it came out of arrogance or pride. It's not the kind of thing you would generally want to share with your friends or family, and you certainly wouldn't expect a favorable response as you shared the news. "Hey, guess what wonderful dream Junior had about our family? We are all going to bow down to him. Isn't that incredible?" Joseph's brothers reacted a little more typically: "Let's teach Joseph a lesson on humility he won't ever forget!" And yet, Joseph's dream was not a dream of pride. Though it led him to the pit, in the end it brought him to reign in the palace. I wonder how many times his imagination kept him focused on that dream when every circumstance told him he was a loser and that he should give up hope. Our imaginations have the power to keep us focused on what is true and who we are when everything else is shifting and those around us don't recognize who we are meant to be.

I believe God will restore your dreams now, even as you read these pages. Perhaps you, like many believers, have thought your dreams were not worth having and have lost hope that they will be fulfilled. But this is a time for you to remember who gave you those dreams in the first place and who can fulfill them as you move from the pit to God's true intent. Let hope arise!

**Dreams are God's secret weapons for revealing destiny.**

Dreams are God's way of invading our imaginations so we can't reject Him with our rational minds or "common sense" filters. God invaded the dreams of Jacob when he was running for his life. After stealing his brother Esau's rightful birthright, Jacob fled to an unknown place and laid his head on a stone pillow to

sleep. In his dream, he saw angels ascending and descending, and God told him that he would come back to that place and settle there with his descendents. Why did God invade Jacob's imagination? Jacob needed to know God's promise because he would face many struggles in the land where he was headed. He needed to know that he wasn't orphaned from his tribe and would return to his forefathers' land. When Jacob did return home after many years, he found out that his brother, Esau, was on his way to meet him. Jacob, full of fear, reminded God of his dream and that God had promised to prosper his descendents in the land of his youth. The picture in Jacob's imagination was still giving him hope as he faced his worst nightmare—retaliation from his brother! God backed up His word, and Esau embraced his brother in tears, accepting him back. As they were for Jacob, your dreams are connected to your destiny and will create hope and vision, even when circumstances are contrary.

When I was 18 years of age, I had a dream that didn't make sense at the time, but which I knew was from God. In the dream, it felt like I was in a helicopter flying about 15 feet above the ground. I saw a vibrant, magnificent African sun setting on the horizon. Shafts of grass swayed in the wind. As the helicopter moved forward, I beheld an open wagon with large vats of food and water barrels silhouetted against the setting sun. I knew I was up on that wagon giving away food and water to people. As we came closer, the grass swaying in the wind turned into the raised hands of people begging for sustenance. Somehow, I knew that this dream was tied to my future destiny.

Shortly after I had this dream, I went to Bible college and pursued my call to full-time ministry. Now, after being involved in ministry for 25 years, I can see how this dream typified my life's call to bring the supernatural food of God's love and identity to those who are starving to know His goodness in their lives. And though I don't live there, the country of Africa is in my blood. Within the last five years, I have visited Africa four times.

My whole family has ministered in Africa, touching its people through healing and compassion. As we pursue God's heart, the dreams inside of us are tilled in the soil of our imaginations and produce life and transformation.

Walt Disney is another example of the power of imagination to birth significant dreams in our present world. Disney said, "Many of the things that seem impossible now will become future realities."[3] His legacy of bringing joy and creative entertainment around the world is unparalleled. His empire continues to plan for the future:

> Walt Disney Imagineering is the unique, creative force behind Walt Disney Parks and Resorts that imagines, designs and builds all Disney theme parks, resorts, attractions, cruise ships, real estate developments, and regional entertainment venues worldwide. Imagineering's unique strength comes from the dynamic global team of creative and technical professionals building on the Disney legacy of storytelling to pioneer new forms of entertainment through technical innovation and creativity.[4]

Walt Disney began to imagine film and animation that would be Christian-based and hold to a high moral standard. Here is an excerpt from his memoirs:

> ...I am personally thankful that my parents taught me at a very early age to have a strong personal belief and reliance in the power of prayer for Divine inspiration. My people were members of the Congregational Church in our hometown of Marceline, Missouri. It was there where I was first taught the efficacy of religion...how it helps us immeasurably to meet the trial and stress of life and keeps us attuned to the Divine inspiration... Deeds rather than words express my concept of the part religion should play in everyday life. I have watched

constantly that in our movie work the highest moral and spiritual standards are upheld, whether it deals with fable or with stories of living action. This religious concern for the form and content of our films goes back 40 years to the rugged financial period in Kansas City when I was struggling to establish a film company and produce animated fairy tales. Many times during those difficult years, even as we turned out Alice in Cartoonland and later in Hollywood the first Mickey Mouse, we were under pressure to sell out or debase the subject matter or go "commercial" in one way or another. But we stuck it out...Both my study of Scripture and my career in entertaining children have taught me to cherish them...Thus, whatever success I have had in bringing clean, informative entertainment to people of all ages, I attribute in great part to my Congregational upbringing and my lifelong habit of prayer...[5]

It's time to awaken Christian "imagineers" to convey God's beauty and message through music, animation, film, and many other artistic expressions with a spirit of excellence. Revival churches ought to be known as the happiest places on earth—not because of animated characters, but because of those who dream of bringing creativity back to the Church and show those outside the true beauty and glory of the Creator expressed in believers' lives. If we have a creative God, let's find ways to show people God's spirit of excellence by using our gifts and talents as supernatural agents of the Kingdom. It is time that our churches and lives reflect the nature of our creative God.

**Revival churches ought to be known as the happiest places on earth.**

## Visions Conceptualize Truth

We have seen how God can activate our imaginations through dreams. Now let's turn to the power of visions. It's amazing how God can interrupt us, even when we are awake, through visions formed in our imaginations.

Peter was bringing Jews into the Kingdom and busily turning the world upside down with the Gospel. But God wanted to get his attention and knew the "way in" was a vision that would tweak his theology. All of a sudden, while praying, Peter was interrupted by a vision of animals that Jews considered unclean coming down from Heaven in a large sheet. He was then commanded to eat them because they were no longer called impure. God then led him to connect this vision, through a series of supernatural events, to the Gentiles finding faith in Christ. It was visual imagery that spoke directly to Peter and created the vehicle for all the churches to embrace the spread of Christianity to the Gentiles throughout the world!

A similar example of how God touches people through visions and activates their imaginations to bring transformation is the story of Count Zinzendorf, the leader responsible for the Moravian movement in the 17th century. His model for 24-hour prayer and worship, as well as modern-day missions, has impacted churches today in bringing revival around the planet. But how did Count Zinzendorf get his inspiration?

> During his Grand Tour (a rite of passage for young aristocrats) Nicolas (Count Zinzendorf) visited an art museum in Dusseldorf where he saw a Domenico Feti painting titled *Ecce Homo*, "Behold the Man." It portrayed the crucified Christ with the legend, "This have I done for you—Now what will you do for me?" The young count was profoundly moved and appears to have had an almost mystical experience/vision while

looking at the painting, feeling as if Christ himself was speaking those words to his heart. He vowed that day to dedicate his life to service to Christ.[6]

Visions and dreams are essential elements of the outpouring of God's Spirit:

> ...*Your sons and daughters will prophesy, your old men will dream dreams, your young men will see visions. Even on My servants, both men and women, I will pour out My Spirit in those days* (Joel 2:28-29 NIV).

When we examine these verses, it doesn't say that these visions and dreams are only to awaken the Church, but all humankind. I believe a fresh movement of creativity in the Body will initiate transformation, both in the Church and within the marketplace. We will see people released to dream again and to dream the dreams of Heaven. We will see prophetic visions reveal biblical truths in ways that will transform limited thinking about God's power and love. I love the promise of Joel 2 because it says that our age, race, sex, or upbringing doesn't matter—God is releasing His Holy Spirit in and through all of us!

Get ready to open up the door through childlike faith, and ask for dreams and visions to flood your imagination.

## Safeguard of Community

As we study the Bible and the way that God works, we know that nothing happens outside of community. God meant for dreams and visions to impact the whole Body of Christ and to be forged and built through community. We must have a vision, not only for what can happen within the Church, but also for how we can build community to transform every sphere of society. Community is the safeguard that keeps us accountable and in relationships where we can father and mother the coming gen-

erations. Joseph's and Jacob's dreams were for the community—they brought prosperity and safety to the nation of Israel. Peter's vision was tested and approved by the church community. Visions and dreams from God, released through the imagination, are pastored and cultivated in the soil of a revivalist community where they can benefit others and be birthed at the right time and for the appropriate season. Fathers and mothers are being placed strategically in order to care for those whose imaginations are brimming with Heaven's creativity. Like Walt Disney, we will be successful through prayer, through valuing people both within the Church and outside the Church who are excellent in their craft, and through teaching them to dream.

> **Visions and dreams are cultivated in the soil of a revivalist community.**

## Imagination and Holy Spirit-Led Adventures

There would be no creativity without imagination. There would be no supernatural anointing without the leading of the Holy Spirit. What happens when you let the Holy Spirit partner with your imagination? Adventures begin!

My husband, Kevin Dedmon, has written an incredible book called the *The Ultimate Treasure Hunt.*[7] This book describes ways of using your imagination to find the treasure inside people. This kind of "treasure hunting" involves asking for clues about the people God wants you to meet in the marketplace and then making a treasure map based on your findings. You then go out to find your treasures, either alone or with a group of other believers. You can

also combine creativity in the arts and make something to give out to someone you will meet.

My friend, Kristina Waggoner, who proudly has a degree in stick figures, has a story about how she used her art in a treasure hunt. She drew a guitar with these words written underneath it: "Jesus wants to play the strings of your heart." She planned to give it to someone she would meet on the treasure hunt. Her group then went to the gas station to fill up before heading out. At the gas station, they looked at their clues and began to ask if there was a man named Mike there. A man overheard them and said that was close enough—his name was Rick. They began to pray for his friend Tom, who had cancer, because both of these clues were on their lists. As they were praying, Kristina noticed that Rick was wearing shorts, though it was extremely cold outside. She also noticed he had a large tattoo of a guitar on his leg! She grabbed her picture and showed it to him, asking if this meant anything to him. With tears in his eyes, he explained that his brother had died in a car accident and that the only item they were able to salvage from the wreck was his brother's guitar with his own blood on it.

As both cars pulled out to leave, Rick jumped out of his car and stopped them from leaving. He said that just moments before pulling into the gas station, he had been thinking of Jesus in Gethsemane in connection with his brother's death. He couldn't believe how accurate this guitar picture had revealed what he was thinking, and he just had to go back to let Kristina know. Jesus really did play the strings of his heart, which led to a significant time of prayer over his life.

The Holy Spirit awakens us through our imaginations to the goodness of God and the power of transformation. All we have to do is listen for the clues and find out what He is up to. We are getting a newsreel, a movie clip, of what's in store—all we have to do is find the right channel!

# Take the "What If" Plunge

When I first came to the Vineyard Church in the early 1980s, they were equipping everyone to pray for the sick. I remember that I wanted to see a person physically healed when I prayed, so I kept asking until it happened! It took me three months, but I was determined to walk in the fullness of my inheritance.

I want you to take the "what if" plunge and ask God to open up your imagination to what is available to you right now. Ask for dreams and visions—clues like the one Kristina Waggoner found that will set people free. Right now, wherever you are, take a pen and paper and write down where you need your imagination to be expanded for it to become supernatural! Remember—if your dreams are big enough for you to accomplish, then they aren't supernatural.

## Imagination Exercise

*Use your imagination and write down what the Holy Spirit wants to do in your relationships. Ask God what you can declare, like Jim Carrey, to see those dreams happen. Ask Him what you can begin to do as well.*

---

---

---

---

*Imagine what legacy you would like to leave behind for future generations, like Walt Disney did. Write down what it would be.*

---

---

*Ask the Holy Spirit to bring to mind any dreams, visions, or prophetic words into which He wants to breathe hope. Now, begin to let your imagination breathe life and faith into those dreams and believe that God will bring it to pass because it is important to you.*

*Now, take time and write out declarations that you can say to affirm and bless your imagination. Ask that it would be fruitful and filled with ideas and creativity to transform others and benefit those around you.*

*Ask now for spiritual mothers and fathers who value your dreams and can come alongside you to partner with you. If any come to mind, share with them dreams and visions that you have. Ask God to connect you with others who can help support you along the way!*

*Take the plunge and ask God for a picture or word for someone you will meet today, like Kristina Waggoner did. Remember, it doesn't have to be perfect, just led by the Spirit! Now put it away and get ready to find your treasure today!*

---

If you want to go even farther, I suggest that you draw or write every day and then give it out to someone you will meet. This will create a momentum for the supernatural power of God to flow through you so that it isn't just an event, but it becomes a part of your lifestyle. Remember, you can do this with friends, in a home group, or at a coffee shop—just go for it!

---

## Endnotes

1. Albert Einstein, http://thinkexist.com/quotation/ imagination_is_more_important_than_knowledge- for/260230.html; accessed December 21, 2011.

2. Jim Carrey, quoted in Jack Canfield, *The Success Principles* (New York: William Morrow, 2004); www.abeforum. com/archive/index.php/t-12669.html; accessed December 21, 2011.

3. "The Religious Affiliation of Filmmaker Walt Disney," *Adherents.com;* www.adherents.com/people/pd/Walt_Disney.html; accessed December 21, 2011.

4. Ibid.

5. Ibid.

6. "Influence of a Painting," *Count Zinzendorf: Christian Biography;* http://victorsotelo.com/website_designs/zinzendorf/zinzendorf_contents/painting_influence.html; accessed December 21, 2011.

7. Kevin Dedmon, *The Ultimate Treasure Hunt* (Shippensburg, PA: Destiny Image, 2007), 83.

Weaverville;
① Wave to woman whose son had died —

② Abstract. q Cross + crown — given to drug addict who really liked it. I didn't know it was her birthday —

# Supernatural Power
# of Creativity

O ne of the most incredible characteristics about the God-
head is that They love partnership. The Father, Son, and
Holy Spirit hung out, thought up this universe, and then
created it out of nothing together. Then They decided to make hu-
manity in Their image of partnering and relationship: *"Let Us make
man in Our image…"* (Gen. 1:26). After forming man and woman,
God gave them a mission: to have lots of kids and be stewards of
God's creation. In making us in His image, His first desire was for
us to be intimate and reproduce through partnership because that is
how He is wired. In fact, all of creation was made to reproduce after
its own kind through intimacy and partnership.

The relationships in the Trinity unfold throughout the Bible,
starting in Genesis. Solomon and David both referred to the part-
nership of God in creation and in ruling the universe. When Jesus
arrived, He introduced us to the Father and explained that He never
made any move apart from Him. At the Father's bidding, Jesus laid
down His life to restore us to relationship with God. Then Jesus left

the scene on earth so we can have relationship with the Holy Spirit. And the Holy Spirit reveals the nature of Jesus! God wants us to know Him and how He relates in partnership within Himself and with us.

It's all about relationship. That's how we have been wired from birth. Look at the way every society finds its cultural identity as it operates in community. In our society, every epic movie you watch, book that you read, team that you root for, or Facebook page you open will have relationship running through it because we are designed like our Father for relationship.

> **We are part of an eternal plan set in motion before the beginning of time.**

Every human being on the planet is a unique expression resulting from the Trinity's imagination and creativity operating through relationship. Each one of us is deeply involved in a partnership with God that transcends our individual lives. We are part of an eternal plan set in motion before the beginning of time. Understanding our relational design is important as we study our creativity and imagination because they were made to function relationally, just like God's creativity and imagination function relationally. God designed His offspring to bring Him glory by reflecting the endless facets of His being, and we reflect these facets through creative partnership in our relationships with God, our mates, our children, our church communities, and the societies in which we live.

One of the truths that intrigues me about God is that in this partnership, He designed it so that we could have a way out of His divine plan. In His plan, He designed us for voluntary partnership, which requires an escape clause called free will. We can choose to

walk away from goodness, Heaven, unconditional love, and above all, relationship with Him. God could have set up eternal truths and told us about them so that we could make a choice on information alone. But He wanted to have relationship with us, and He made full provision for the restoration of that relationship when Adam and Eve opted for the way out of it. The whole purpose of sending Jesus to die in our place was because He wanted us back in relationship and partnership.

Significantly, Christ didn't wait to launch His disciples into partnership until they were "mature." He decided to trust His "unlearned" disciples to spread the Gospel so that everyone on the earth could know about Him through His true sons and daughters. People won't get healed, born again, or filled with the Spirit without our participation in the spread of the Gospel! Talk about childlike trust! We are in a divine partnership! God has even given us the power to forgive or not to forgive sins:

> For if you forgive men when they sin against you, your heavenly Father will also forgive you. But if you do not forgive men their sins, your Father will not forgive your sins (Matthew 6:14-15 NIV).

He also allows us to choose how closely we want to walk in relationship with Him. Just as teenagers can live in the same house as their parents, yet choose not to live "close" to them in partnership, so we can choose to be children of God, yet live very distant from God in our hearts. On the other hand, we can choose to have the closest partnership with Him, in which we know what He thinks, believes, and acts and what is important to Him. In this place of intimacy, we also discover just how close He wants to be with us.

Our first example of God's desire for partnership with humanity happened in the Garden. God gave Adam the privilege of partnership in what He created:

*Now the Lord God had formed out of the ground all the beasts of the field and all the birds of the air. He brought them to the man to see what he would name them; and whatever the man called each living creature, that was its name* (Genesis 2:19 NIV).

I humorously enjoy the wording in this verse, that God "wondered" what Adam would name the animals. It sounds like God was excited to watch His son participate in defining the destiny of what He had created. I can almost see the Trinity busily creating the colorful variety of animals, reptiles, and insects and saying, "Hey, I bet Adam is going to have fun naming this one! Hey, look at all the legs on this insect. I wonder if Adam will wonder why We only gave him two!" (I know some of you out there have wondered the same thing!) God wanted Adam to creatively call out the destiny of each living thing, not only to give him personal ownership in the Garden, but also because He wanted humanity to partner with Him in the creative, prophetic process. And things still haven't changed. God wonders what you will prophesy over the people He has put around you, over your church, your job, and your life. He wants to partner with you supernaturally!

## Unlocking Supernatural Creativity

When most people think of creativity, the word *supernatural* doesn't come to mind. They think of a person who is talented or gifted with a certain ability, but they don't think of supernatural power being transmitted through what is created. We need to remember that God's ability to create, which He has shared in various measures with us who reflect His nature, is supernatural. All you have to do is go outside and see cloud formations, a beautiful sunset, or expanses of nature or watch a baby being born to understand that not only is God beautiful and majestic, but also that He is always supernaturally creating beauty out of love for us.

The dictionary definition for *supernatural* is "of or relating to an order of existence beyond the visible observable universe; *especially*: of or relating to God."[1] Another meaning is "departing from what is usual or normal especially so as to appear to transcend the laws of nature; attributed to an invisible agent."[2] From Moses to Elijah and Elisha, the Old Testament reveals that the laws of nature were subject to those who operated in partnership with a supernatural God. Then Jesus arrived and put a superior partnership on display, one that He shockingly insisted was available to all who would believe in Him.

We have super hero power like our Dad in heaven.

He taught His disciples that whatever they asked in prayer, believing they had received it, they would have (see Mark 11:12-25) and that they would do even greater works than He did (see John 14:12). We have been given supernatural power like Jesus through our relationship with God. If He is a superhero, then we are superheroes in the making! We must understand that we are not merely finite human beings; we are spiritual beings who have been given eternal life and now have the keys to the Kingdom (see Matt. 16:19). You are not ordinary; you are supernatural. You have been called to divine partnership that opens up the supernatural realm and gives you permission to release His supernatural power where you have authority, compassion, and access.

Many of us have not understood the power of supernatural creativity because we haven't been looking for it. But supernatural creativity is recorded all throughout the Bible. The craftsman Bezalel is the first person recorded in the Bible who was filled with the Holy

Spirit (see Exod. 31). We see this anointing coming on him as he is commissioned to build the ark of the covenant and the other parts of the tabernacle. It is interesting that the Spirit didn't fall upon the priests or the prophets, but on the craftsmen who were making a place that would house the very presence of God.

Another example of supernatural creativity in the Bible is Joshua's strategy for invading the city of Jericho. This superhero did not advance with mighty men armed for battle. He used the power of anointed unison, both in sound and intent, to topple the walls of Jericho (see Josh. 6). David also released creative sound when he played over Saul and released him from demonic torment (see 1 Sam. 16:23). (In both these examples, notice that creativity has both constructive and destructive dimensions. The anointing of spiritual creativity not only builds the work of God, but it also destroys the work of the enemy.)

David also danced with all of his might as he led the procession when the ark was brought back to Jerusalem in victory (see 2 Sam. 6). I believe David's people received greater freedom, joy, and a child-like spirit as they saw their king dance unashamedly with all of his might to celebrate the presence of God coming back to His rightful place. Interestingly, God honored David's request to build the temple, which his son, Solomon, built, even though the temple wasn't inspired by God, but David. God honored David's request, however, because of His relationship with David. In other words, God wants to know our desires and help fulfill them because we are in a family relation-ship. We are in a divine partnership in which God also wants to an-swer our requests.

The prophets in the Old Testament released healing through creative prophetic acts and prophetic words. They also participated in creative miracles that brought solutions to impossible situations, as when God made an axhead lost in a river float to the surface (see 2 Kings 6). Jesus used creative stories when speaking to the crowds

to reveal their hearts. On one occasion, He wrote in the sand, which made all of the accusers set on killing the woman caught in adultery leave their stones and walk away (see John 8:1-11). Talk about supernatural, prophetic art!

God has a plan to reveal people's hearts through creativity. This creativity was never meant to be ordinary, but supernatural—and at the same time, it was meant to be the natural expression of every supernatural believer who desires to carry His presence and bring the Kingdom to earth. Creativity is a way we release the supernatural through our partnership with a God who always likes to do things differently! If you haven't picked up on the fact that He likes variety, just look out the window or look in the mirror!

Scripture reveals that God is also into architectural design. He partnered with Noah and designed the ark to house two of every type of animal. He gave specific designs to Moses for the building of the tabernacle, and later gave an intricate design blueprint for the temple of Solomon. God loves interior design and culinary arts as well. This was the supernatural creative expression that most impressed the queen of Sheba:

> *When the queen of Sheba saw all the wisdom of Solomon and the palace he had built, the food on his table, the seating of his officials, the attending servants in their robes, his cupbearers, and the burnt offerings he made at the temple of the Lord, she was overwhelmed* (1 Kings 10:4-5 NIV).

**Anointing and healing flows through what we touch and create.**

God is also into fashion. That's right! Exodus 35:35 states that God endowed the makers of the tabernacle *"with skill to do all kinds*

*of works as craftsmen, designers, embroiderers in blue, purple and scarlet yarn and fine linen, and weavers..."* (NIV). In the New Testament, we see that fabric can carry an anointing of supernatural power. The woman who had an issue of blood was healed when she touched Jesus' garment (see Matt. 9:20-22). And Acts 19:11-12 speaks about Paul's handkerchiefs and aprons healing people as they touched them. We have seen so many people healed just by touching an art piece that someone has made in His presence in childlike faith. God has called us His anointed healers, which means that we carry the supernatural in what we create!

## Testimonies of Supernatural Creative Partnership

I'll never forget when I began to understand this more fully through testimonies that began to flood in of how creativity was setting people free and releasing God's miraculous power and revelation. One of these testimonies is of an encounter in the marketplace with students from Bethel School of Supernatural Ministry (BSSM). I train the BSSM students to go out and release God's power through supernatural creative expressions such as dance, drama, art, face painting, writing, balloon animals, and body art. When we do arts in the marketplace, we first fill up in His presence by remembering His goodness and drinking in the "new wine" of the Holy Spirit until we become overflowing carriers. Then we ask the Holy Spirit what He wants us to create and for words of knowledge about the people He wants us to touch. We give the students the option of either creating something before we go out or doing something when we arrive. We want each team to pursue healing and prophetic ministry (encouraging words according to First Corinthians 14:3) through artistic forms.

On one of these occasions, one of my team leaders took some first year students, who had never done anything like this, out into

the city. They went to the Rescue Mission, where homeless people were being given shelter for the night. Crystal McDaniel, my team leader, asked Estelle Barbey, a first year student from England, if she would paint a prophetic art piece for one of the homeless men waiting to get into the Mission. This was out of her comfort zone and definitely out of her grid in regard to the supernatural. But she looked at her oil pastels and began to paint his portrait in tangerine orange, lemon yellow, and lime green.

At first, she couldn't keep her eyes off of his unkempt hair, odor, and drunken state. As we had trained her, however, Estelle kept asking the Holy Spirit for what to do next. He told her to put a smile on the man's face, which seemed odd to her at the time. After she did that, she explained to the man that the portrait was a representation of how God saw him. Immediately, the man began to curse and say that he was a loser, a drunk, and far away from God. She repeatedly told him that it didn't matter what he had done—this was how God saw him, and He loved him just the way he was! The man said he had always thought that God was angry and disappointed in him. But every time he affirmed that he was a loser, Estelle pointed at the picture, reaffirming God's unconditional love.

Eventually, the team had to leave, and this man took his portrait with him. Estelle was relieved when they had to leave and didn't see anything supernatural in the encounter. But though it seemed to be the end of the story, it was only the beginning.

On the following Sunday morning, this man was picked up, along with others from the Rescue Mission, to attend Bethel Church. He began to talk to the bus driver and showed him the picture Estelle had drawn for him. He asked the driver, "Do you think if God loves me just the way I am, He would heal me of my cold?" The bus driver assured the man that God did love him and encouraged him to ask God for healing during worship that morning. As worship began, he closed his eyes and said, "God, if this

picture is real and You love me the way I am, will You heal me?" Then he opened his eyes. It so happened that this man was blind in one eye. He hadn't even thought to ask God for healing from blindness, but God was *that good*—as the man opened his eyes, he was completely healed of blindness!

This man began to shout and scream in the middle of the service: "I can see! I can see!" Immediately, our pastoral team came over to hear the incredible story. One of the pastors asked the man if he had any other physical needs and found out that he was deaf in one ear because he was lacking an eardrum. The pastors prayed for the man. Immediately a new eardrum formed, and the man began to hear from his deaf ear. He also had a damaged hand that was healed that morning.

When this man was interviewed about his healing the following week, he linked his healing back to Estelle's picture. I heard the testimony and longed to talk to him, but didn't know who he was. Thankfully, God set it up! Two months later, this man was in church and stood up for prayer for joint problems. I prayed for him, and he was healed of arthritis! He told me that this was just like when his eye opened and his ear was healed two months before. I asked him if he was the man with Estelle's picture who was healed in worship. He nodded. So I asked him if he still had the picture. He said, "Yes, for once I was blind, but now I see. I carry it around to remind me of who I am!" This is the power of supernatural creativity!

**God radically heals through supernatural creativity.**

# Breakthrough in Missions Through Supernatural Creativity

In March 2011, I led a team of over 35 students from BSSM on a missionary trip to the Philippines. Before we left, I had each of the students take a canvas, ask the Holy Spirit to show them something to draw that would transform the Filipino people, and then paint or draw something to give away there. One of the first year students, Naomi Leppitt, who had never really drawn before, made a painting of a large tree with rays coming on it and the root system going deep into the soil. We were privileged to influence many governmental leaders on this trip, and one of them was a chief justice from Manila.

Naomi felt like she wanted to give this man her painting, so as we gathered together to pray for him, she presented it to him. He looked astonished and replied, "Do you know what my name means?" She said she did not. He said, "My name is Puno, which means 'tree' in Filipino. I am putting together an act where Filipino prisoners will plant one billion trees in this nation to bring reform and restoration to our land. The tree you drew looks exactly like the tree we will be planting!" Of course, we were all astounded. This simple prophetic painting now hangs behind the desk of the chief justice of Manila, reminding him of God's words over his life. There is so much supernatural power released through creativity!

These are stories to whet your appetite. God wants creativity and supernatural power to flow through us in business strategies, in arts and entertainment, in how we do church services, in how we train up our children, and in every area of life. Remember, it starts with being childlike in nature, having faith to step through the door of impossibilities, and believing in who we are as supernatural beings.

# Finding Our Identity

One of the most vital discoveries we must make is who we are in divine partnership with God. Moses made such a discovery after 40 years in the wilderness. God appeared to him in a bush and told him to go back to Egypt because the great I Am would be with him. Moses started to argue with God and put a lot of disclaimers on his worthiness to be Israel's deliverer. He had so many reasons he was not the right one, but his inadequacies were not the point. Over and over again, God asserted that He would be with him, showing him miraculous signs through his staff so he knew God would back him up. This is such an important illustration for us as supernatural, creative people! God is going to back us up. Moses thought his staff was ordinary, but with the power of the Holy Spirit it became miraculous. Because He is with us, He will anoint our identity and calling to supernaturally transform people and set them free!

So what are you waiting for? Do you know who you are? Let's go and set God's people free!

# Supernatural Creative Exercise

- *Ask the Holy Spirit for a person who needs encouragement through you today. Remember that prophetic words must be encouraging, uplifting, and comforting, according to First Corinthians 14:3. Then, ask the Holy Spirit what you could do creatively to minister to that person. The options are endless, but here are a few ideas:*

    *A gift with a prophetic card;*

    *A prophetic art card with an interpretation about the picture inside;*

    *A prophetic song you can sing over him or her;*

    *Culinary arts to touch his or her stomach;*

> *A gift or service that he or she personally needs that you have or could provide.*

- *After you create what God shows you, ask the Holy Spirit to anoint it with supernatural power for healing, breakthrough, and prophecy.*

- *Make a plan to give it to the person, and ask that person what it means to him or her.*

- *Keep a journal about what happens. You are in for a supernatural ride as you do this for others!*

*If it doesn't go well at first, do not be discouraged. Continue doing this until you see breakthrough! It's all about learning, not about being perfect!*

# Endnotes

1. *Merriam-Webster Dictionary Online*, s.v. "Supernatural"; www.merriam-webster.com/dictionary/supernatural; accessed December 21, 2011.

2. Ibid.

# *Redeeming*
# *What Was Lost*

In my senior year of high school, I was offered an art scholarship, but I turned it down because I didn't feel it was valuable in the Kingdom or in ministry, to which I was called. I was ignorant of God's creative design in me, and devalued the creative impact I had received through my family line. Thankfully, God has realigned my thinking about the value of my artistic gifts in ministry and that impact has been restored to me. In the process, I have gained a passion to see the whole Church come to share this value for creativity, which will open up the generational lines of blessing from those who were anointed in the past to influence those in the Body who want to create.

There is enormous need for creativity in the Body of Christ. We are getting ready for a great awakening in the hearts of people across the globe. Worship where people can express their love to Him in all kinds of creative ways is becoming a top priority. For instance, at Bethel Church we have painters, dancers, and worship leaders who all lead us into the presence of God on Sunday nights. The Bride of

Christ is taking her position as joint heir, restoring all things back to their rightful Ruler. Her influence is increasing, as those who abide in Christ and live supernaturally carry the Kingdom core values that inevitably stimulate cultural transformation and reform. However, it is essential for these core values to be translated through arts, entertainment, and media in order to have widespread impact.

This is why Paul stood on Mars Hill, where all of the great orators in Athens had stood, and found a point of cultural identification by which to speak to them about Jesus. He quoted their own poets and demonstrated that he was very familiar with the many idols that filled the streets of Athens. Then he told them the true identity of *the unknown God* they had enshrined (see Acts 17:23). Paul knew that speaking the language of the culture was the way into people's hearts. But though he used a vehicle that was relevant to the Greeks of that time period, he didn't compromise the Gospel; rather, he made Jesus stand out as different than the other gods they worshipped. When we speak the language of our people in our supernatural, creative expressions, our message will not only be relevant, but transformational.

**The arts have the power to shift and influence.**

The arts have the power to shift and change nations by influencing morale and public opinion. Their force has been greater at times than the power of the strongest weapons. Consider what happened when Gideon's army of only 300 men surrounded Israel's enemies at night. Their strategy was to blow trumpets and smash jars with torches inside. I have never heard of an army using trumpets to fight battles—nor do I know of any military ruler who would presently

sanction that—but that's what happens when you partner with supernatural creativity! When the enemy heard the sound of the trumpet, all of them turned on each other, killing one another with their swords (see Judges 7:22).

Military strength wasn't what started the Second World War or led to a million Tutsi Rwandans being massacred in the 1994 Rwandan Genocide. Those wars were started through the airwaves, linked to media and arts. Newspapers and radios fed these countries a daily diet of bigotry and hatred, which influenced whole nations to turn their backs on those they knew and try to wipe out a whole race of people. If the arts and media can be used for evil, think about what they can do if they are put into the hands of those who have intimate relationship with the Father of life.

## The Role of the Church in Stewarding the Arts

Value for creativity and the arts is returning to the Church. Rick Joyner said:

> ...Art belongs to God, and He is going to take art back. Art is a basic form of prophecy, and there is a beauty and anointing about to come upon a host of holy artists whose prophetic art will burn away the fog that is now over it, just like the sun burns away the fog in the morning.[1]

If we are going to see this happen, then we as Christian artisans, musicians, and creatives need to begin to create in live worship settings where God's presence can come upon people. The arts need to be valued and taught to our children and those who are going to be the major influencers in society. Our creativity has to move outside the four walls of the Church, where we can impact the culture through prophecy and healing.

I love the city of Redding where I live! I want it to be a cultural hotspot for revival. Some time ago, I decided to submit my artwork,

as well as some artwork and photography created by School of Supernatural Ministry students, to be showcased for three months at City Hall. When our work was accepted, I began to ask the Holy Spirit what would be relevant and meaningful to those who would be going by the artwork every day in that governmental building. I decided to go with the theme of places or people in Redding. We wanted to prophesy to our city through art, so they could see it prosper through the lens of God's goodness.

The city later had an open house for the artists who had displayed their work. Our artwork was displayed on the second floor of City Hall. People mingled with us while eating hors d'oeuvres, and we began to share why we had chosen certain subjects. Like Paul on Mars Hill, we found a common cultural language in which to engage others. During the open house, people from the community and governmental offices began to share with us what they loved about Redding. On several occasions, people just stared at my portraits, saying that they could almost sense what the person depicted was feeling. I was then able to share stories about the people in the portraits.

One of my paintings showed a baby in the womb with the caption, "Some voices may never be heard." Many people stopped and stared at this painting. Some cried. I talked with most of them about the power of a life, asking them the question, "Who will protect the voices of those who cannot speak for themselves?" I didn't have to argue or defend—the baby in the painting spoke louder than words. My team and I were able to pray for physical and relational healing for so many. The door was wide open thanks to the relevance of the artistic vehicle we used to release the message of redemption in a relevant way.

Another interesting observation came from people who worked at City Hall. As they walked by our paintings on the second floor, some commented: "I don't know what it is, but whenever I work on

this floor, I just feel better. I think it's something about the artwork." I heartily concurred.

## History of the Arts in the Church

If you study First and Second Kings, you will see that when a righteous king ruled Israel there was favor, but without one, evil abounded. When people were following the Lord, there were festivals celebrating His goodness, the land and people prospered, and creativity blossomed. The cultural arts reflect this in history. Music and worship thrived under King David, a man after God's own heart. Under Moses, the artisans came together to build the tabernacle, and under Solomon, craftsmen built the temple. When godly people partner with God's presence, creativity flourishes and benefits the people and the land.

> **Revival releases creativity in the church and in culture.**

After Christ's death, Christianity began to influence the arts world and became the dominant theme of medieval art. Christian scholars established centers of learning throughout Europe. Wherever Christianity spread, literacy, artistic design, and learning emerged. Christianity was the inspiration for poetry, plays, and works of art. What the Church didn't inspire, it dramatically influenced, including secular works such as Geoffrey Chaucer's *Canterbury Tales*, which describes a pilgrimage to Canterbury Cathedral. I have personally enjoyed meandering through the museums in Europe, where I have seen beautiful paintings and tapestries depicting Jesus and His story, which definitely was the major

subject in art until humanism began to take the central place in creative expression.

Christianity influenced the arts not only in Europe, but also in other regions where the Gospel had spread, as is shown by the collection of medieval Ethiopian Christian art donated to Howard University in Washington, D.C. (This should come as no surprise; an Ethiopian court official became one of the first Christians. See Acts 8:26-40.) The Church was the major patron of the arts through the Middle Ages and until the Renaissance. It supported and commissioned artists from the monks on the Scottish island of Iona to Michelangelo in Rome. Gradually, however, the focus of adoration began to change. As it had in the Old Testament, deep devotion to God turned into idol worship. Church icons (statues or portraits of Jesus, saints, and other Christian symbols) became deified objects, leading many to idol worship. They took the place of prayer and faith, becoming a "form" of religion and replacing the power of grace and relationship. Holidays and festivals came to involve paying tribute to a local icon or relic. People prayed to these idols, sadly expecting miracles from them, not God.

The Protestant Reformation occurred somewhat in reaction to this idol worship, which plagued the Catholic Church. Superstitious indulgences were paid to idols in order to earn graces into Heaven. Again, what had started out as beauty to reflect and glorify the Creator led to idolatry and exploitation by greedy and wicked men. Martin Luther and others were so outraged by this abuse in the Church that they did not separate the sin of idolatry from the prophetic and powerful nature of the arts to glorify God. They reacted out of fear, which has had underlying repercussions on Christianity and its ability to influence culture. If it was a statue, painting, or ornamentation, it was considered evil. Thus, Protestant churches were barren and colorless.

This reaction brought a distorted view of God's nature to people. God, who is versatile, creative, and colorful, became faceless, far away, and separated from artistic beauty and expression. This was quite different from the elaborate embroidery on Catholic priests' garments and the images that represented God and His mission painted on the walls and ceilings of cathedrals. In reaction to sin and in fear of idolatry, the Protestant Reformation erased creativity from worship, while many Catholics were stuck in a form of religious superstition, distorting the beauty of what the artists had originally intended.

During this era, many artists began to change their focus. Rather than being influenced by the Church or God, they began to divert their attention toward humankind, and the humanist movement, which began in the Renaissance (followed by the Enlightenment), was born. God was largely written out of the equation in this movement because the Church had abandoned its role in influencing the culture. People had to write about something full of life, and when the Church lost its creativity, it gradually lost its voice and cultural influence. When evil abounds, godly creativity is stunted. God never meant us to live in a colorless world to avoid idolatry. If He had wanted this, He would have made us all blind.[2]

> **The enemy cannot create; he can only intimidate.**

## Taking Back What Is Rightfully Ours

It is our time to awaken the Church to the power of supernatural creativity inside each one of us. As we collaborate with His Spirit,

the Church will once again be filled with wonder, beauty, and creativity that give glory to God. I believe this is what the enemy fears. If we understood the power of sound, visual art, film, writing, and creativity to bring the Kingdom of God to earth, we would stand up like Paul did on Mars Hill and let the truth be known! This is not a time for us to let the enemy continue to keep what he does not own! Jesus gave us the keys to take dominion. It's time to take back places of influence for God and see His beauty, holiness, and Gospel become the healing fragrance to restore people back to right relationship with Him. Again, the enemy cannot create; he can only intimidate. In Zechariah 1:18-21, God invites us to see how the power of creativity will destroy the division of nations:

> Then I raised my eyes and looked, and there were four horns. And I said to the angel who talked with me, "What are these?" So he answered me, "These are the horns that have scattered Judah, Israel, and Jerusalem." Then the Lord showed me four craftsmen. And I said, "What are these coming to do?" So he said, "These are the horns that scattered Judah, so that no one could lift up his head; but the craftsmen are coming to terrify them, to cast out the horns of the nations that lifted up their horn against the land of Judah to scatter it."

The enemy comes to kill, rob, and destroy. He wants to divide families, nations, churches, and people's lives. When people are creative, the enemy fails to have power because he has nothing that can stop God's creative sound. As with Gideon, a trumpet in the hand of a mighty spiritual warrior has more power than legions of armies. This is why the demon had to leave Saul when David played his stringed instrument, why the walls of Jericho fell at the sound of unified voices, and why the prison doors flung open when Paul and Silas were singing praises in prison in Acts 16. Creativity terrifies the enemy because no weapon can stand against God's people as they use it for God's glory.

We wonder why there is so much drug abuse or divorce among the gifted in the music, arts, and entertainment industries. The enemy knows that this is the place of major influence and that the Bride has not yet assumed her position over this sphere. We are beginning to realize that it's up to us to steward and protect those with anointing to rule and have influence. As we take responsibility to father and mother the creatives growing up in our midst, we will see the kingdoms of this world become the kingdoms of our God. We are also called to raise up the Daniels and the Esthers in the Body of Christ who can influence the kings of the entertainment and arts community through prophetic counsel and godly wisdom. God is releasing a Mordecai spirit upon those who can guide them to make the right decisions for such a time as this and defeat the enemy's plans.

## Take Your Sword

Bob Jones, a prophet and father in revival, delivered a prophecy about how we are to take back the arts:

> There is a release of the sword of the Spirit, which is for our offense, not for defense. The Lord is looking for a people who are raised up in warfare with the sword of the Spirit, which are the keys of the kingdom, and will begin to invade where the enemy has come in. The sword is going to take back the crafts, the gifts, and music. As we begin to take back what we gave away, we will begin to hear the new music that will bring forth faith, crafts that will reveal Christ, and inspired pictures that will literally be prophecies a hundred years from now—these pictures will carry a prophecy as long as they survive. These inspired pictures will speak the same language all over the world, for the picture itself will speak the language of Christ.[3]

Today, saints are emerging who will give honor to God in what they create—prophesying through images, fashion, photography, visual and performing arts, literature, architectural design, and culinary arts in order to bring glory to the Creator. They will use all types and forms of communication and will be skilled in their crafts, gaining favor with God and people. It is time for us to take back what has been rightfully ours! People still travel around the world to visit the great cathedrals in order to learn about architectural design and to see the beauty of what was created out of love for God. Handel's *Messiah* and so many other wonderful symphonies were written through visitations with God and are still influencing both the Church and society. This is the power of supernatural creativity working through Spirit-led artisans in the Church! As revivalists, we have to ask ourselves how we will be remembered. What poetry, books, art, films, and architecture will mark our belief about a creative God who is to be worshipped in spirit and truth? How will history record our journey? What inspired paintings will continue to prophesy for centuries to come?

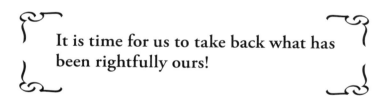

It is time for us to take back what has been rightfully ours!

Darren Wilson, writer and director of the films, *Finger of God* and *Furious Love*, gives us a picture of revival around the world from the vantage point of someone who wasn't sure if it was really true or not.[4] We need to give the world the raw, unedited version of life that is real, full of ups and downs, and not always perfect. If we don't record it, how will they know? We need to get the cotton-candy version of the Gospel out of our mouths, stop watering down the message, and tell it like it is! This is the Jesus worth dying for and worth proclaiming. We are about to write scripts, books,

poems, paintings, and songs about the depths of God's love and His Kingdom. I believe there will also be relationships akin to the relationship between J.R.R. Tolkien and C.S. Lewis. Creatives will once again meet at the pub of the new wine and dream of what could be. There will be a resurgence of novels that will once again impact both the Church and the world. I believe many of you who are reading will be part of this mighty host. The stirrings have begun, and God is calling out to you—create!

I remember growing up during the Jesus People and Charismatic Movements. We sang songs like "Here Comes Jesus," the Holy Spirit dove was on every Bible, and you knew that you were a Christian by the bumper sticker on your car. Now we are entering into a new phase, where what marks us is our passion and worship for God, our childlike spirits, healings, signs, wonders, and Holy Spirit-led creativity. Now it's time to get the word out through the sound waves. We are starting to realize that God has designed the Internet, Facebook, blogging, inspirational movies, video games, and entertainment to benefit His purposes and that they are created for our benefit, not the enemy's.

Daniel was pure and undefiled because of his faithful relationship with God, and this enabled him to grow in favor with God and with people as he advised kings who were not of his faith. We should not be afraid of what God has engineered for our benefit, but instead realize that He means us to steward these riches, just as in the Exodus, when Israel took over the goods of Egypt in order to fulfill their divine purpose. Everything Egypt had prized became the Israelites' inheritance. This is how musical instruments were brought into Israel and how they received clothing, gold, and other resources to sustain them through the wilderness. In the same way, we have to know that God is setting us up to produce the best movies, write the best scripts, have the best business ideas, and come up with the most mouthwatering delicacies to eat—because we can turn these gifts that

people in the world have developed into opportunities for God's Kingdom to come. God wants everything to glorify Him and to have a purpose for good, not evil, which He has entrusted to us to steward. How many souls could a contemporary Daniel, who counsels a president through Holy Spirit-led wisdom and creativity, impact?

## Welcome Home

As we value creativity in the Church and redeem what was lost, the artisans will return home because they are valued and have significance. One of our School of Ministry students, Todd Wilson, was restored in his supernatural, creative destiny as an artisan—and began to restore others to theirs—when he went back home after finishing first year:

> I talked to a glassblower, who sculpts and paints as well. He has struggled with his gift and how it functions in Church. He was even told that he should set aside his art until after he retired and focus on other "more important" areas of work and service. I spoke about the seven mountains of cultural influence and afterwards he came up for prayer. I thanked him for pursuing his art and paving the way for others in the Church to do the same. This shocked him because of his past experiences. He was so encouraged that he started looking online for more info. He found the phrase "prophetic art," which was a totally new concept for him, and every link pointed him toward Bethel! After this, everything changed for him. He began to get "downloads" from God for new sculptures that he believes are connected to the prophetic release of breakthrough, and he's looking for ways to incorporate art forms into worship services!

Let's call the artisans back to their rightful position as prophetic voices both inside and outside the Church!

Why don't we see more people encourage creative people to pursue their dreams and calls? Many of us have been taught that we will be tainted if we pursue creative industries or governmental positions, so we tend to not encourage those who have a destiny in these spheres. Whose voices are we listening to? This never stopped King David or Hezekiah from being rulers, and it shouldn't stop us. It baffles me that we can think the enemy has more power to deceive than God has to keep us morally pure. We shouldn't be intimidated by what the world has produced for evil when we have the Creator of the universe backing us up!

> **We are called to influence the influential in society.**

Again, there is power in community. Jesus never sent the disciples out one by one. As our churches open up the door to these artisans, they will be able to understand community and be fathered and mothered by the Body of Christ. It's time we value creativity and release excellence through Holy Spirit-led art in worship and in Church life. Then we can begin to influence those who have influence in the arts realm as we find a place for them of influence in their chosen field. God wants to give us the spoils of the enemy and see His light shine in the darkest places. One prophetic word can change the life of a mega-producer or a top singer in Nashville. The world needs to know what unconditional love is. Who will show them? What love song will break off the spirit of divorce as people listen to it? These are days for a new emerging breed to

arise, those who are not afraid to take back the spoils as the Israelites did, just as Bob Jones prophesied.

## *Shifts in Our Culture Toward Creativity and the Arts*

We need to understand the times in which we live, just as Paul understood:

> *Though I am free and belong to no man, I make myself a slave to everyone, to win as many as possible. To the Jews I became like a Jew, to win the Jews. To those under the law I became like one under the law (though I myself am not under the law), so as to win those under the law. To those not having the law I became like one not having the law (though I am not free from God's law but am under Christ's law), so as to win those not having the law. To the weak I became weak, to win the weak. I have become all things to all men so that by all possible means I might save some* (1 Corinthians 9:19-22 NIV).

The more we are aware of the types of people in our society and the situations in which they live, the more we can reach them. If we can partner creatively to bless and touch their deepest needs and desires, we will have touched Jesus.

We need to understand the trends and the way of the future. Daniel Pink wrote *A Whole New Mind,* a long-running *New York Times* and *Business Week* best seller that has been translated into 20 languages. This book gives us great insight into the shifts that are happening in our world:

> The last few decades have belonged to a certain kind of person with a certain kind of mind—computer programmers who could crank codes, lawyers who could craft contracts, MBAs who could crunch numbers. But the keys to the kingdom are changing hands. The

future belongs to a very different kind of person with a very different kind of mind—creators and empathizers, pattern recognizers, and meaning makers. These people—artists, inventors, designers, storytellers, caregivers, consolers, big picture thinkers—will now reap society's richest rewards and share its greatest joys.[5]

Pink also believes that we are moving from an informational age to a conceptual age, where "high concept" and "high touch" aptitudes will be valued. "High concept" has to do with patterns and opportunities; creative, artistic, and emotional beauty; and the process of bringing unrelated ideas into something new, which means that we are learning to think through ideas and synthesize them into new patterns and ideas. "High touch" centers around the ability to empathize with others, to understand human relationships, to find joy in one's self and to bring that joy to others, and to pursue meaning and purpose in life.[6]

We are in for another Renaissance. We need to understand that we can keep it centered on what people can do, or we can take advantage of the situation and turn people's hearts back to God through creative thoughts and expressions, which are becoming valuable commodities. It is time for the Church to listen to the voice of society and be Jesus! Let's introduce them to the Man who was anointed with joy above His companions, the One who was moved with compassion and healed all those who were afflicted, and the One who spoke in parables to bring hidden meaning and reveal an eternal Kingdom.

## Shifts in Church Structure

I believe there has also been a changing of the guard within the Body of Christ. We are seeing the entire fivefold ministry described in Ephesians 4 being valued and activated in the Church. There are apostolic centers where people value strategic thinking, rela-

tionships, and the prophetic voice of their people. Visions are being awakened and dreamers are dreaming again. Creativity in different forms is beginning to reemerge and become a vital part of planning and strategizing. We are starting to think about how we can bring more of God's presence into every part of the Body, breathing new life into an old wineskin predominantly made up of teachers who liked things to stay the same. As the world advances, so the Church is advancing, but through eternal Kingdom core values and with people whose leadership style is becoming flexible to accommodate the new structure. Life as we have known it is changing. The Church is expanding its horizon to encompass city, regional, and global transformation. We are not just thinking about what would benefit us or our congregation alone. Churches are partnering together not only for prayer, but also for creative strategies to bless their cities and communities.

We bless our city and call it our parish.

We are seeing this shift happen in Redding and in other places. Churches desire partnership with and transformation in all churches within their community, as well as strategies that will gain influence into the hearts of their cities. How do you know when you are making an impact? You know when people hire you for a job simply because you come from a church that has become known for having people of excellence and honor, which is happening at Bethel Church. You know when you stand in line at the supermarket and the checker remarks, "Oh, you must go to Bethel, because you're so happy and so nice!" Churches should be known for what's happening on the outside. We bless our city and see it as our parish.

In Ventura, California, churches have adopted hotel rooms to house the poor and help disciple those who have nothing. I ministered in this city for many years and have witnessed churches coming together in partnership to transform their city. We have seen so many people get touched on the beach and in business areas as churches partner together through supernatural creative expressions to reveal Christ's love to others. As I was ministering in the city with two different churches, I remember the pastors telling new believers which church would be best for them to attend. Let's work together for every church to be filled, not just our own.

## *Take It Back in Supernatural Color*

Psalm 126 is a song of ascent describing God's restoration for the captives coming back to Zion. It is a vivid description of how I feel about the Church taking back what we have lost in creativity. I have taken the liberty to rewrite this psalm as a parallel to restoration of the arts:

> When the Lord brought back creativity to the Church, we were like those who dreamed. Our mouths were filled with laughter as we saw churches create murals over dilapidated storefronts. Our tongues were filled with songs of joy, written by those healed of AIDS. Then it was said amongst the churches around the globe, the Lord has done great things for us, and we are filled with joy. Restore our fortunes, O Lord; let the people in the Church dance again; let the artists create and the singers sing a new song of joy. Let everyone celebrate its return. Let us go out into the places of our city's need and bring the sound of freedom and joy, carrying the broken back home, welcoming them back to the Father's arms.

₂ and dream is for the Church to be awakened to her full
, in creativity within the culture. Let's partner with the cur-
₋₋₋₋ ₋rends that Daniel Pink addresses, prophetic words from those
in revival, and God's strategies for impacting culture through the
ages. Let's say yes to a fresh move of creativity to sweep through our
churches. Let's dream again and welcome home the gifted, misun-
derstood, creative prodigals. Let's find a place for them to grow—
get them an easel to paint on, a Macbook Pro to write on, or a dance
floor to dance on. Let's design classes for them to learn how to create
supernaturally. Let's open our doors for a fresh visitation of joy and
grace to be released in our churches and communities. It's time the
Church looked like the Creator and not a funeral parlor!

## Let's Start NOW!

Put in the declarations you want to see for restoration of the
Church:

1. *I welcome creativity back into the Church. I declare _____*
   *_____ will once again*
   *be valuable in the Church.*

2. *I welcome back the artists and the creative people back to*
   *the Church. I declare that they will _____*
   *_____.*

3. *I declare that, once again, the creative people will be raised*
   *up in the Church who will _____*
   *_____.*

4. *I declare that the Church will come up with creative strategies*
   *to _____*
   *_____.*

5. *I thank you for the anointed craftsman and artisans who*
   *have changed history. Let their ceiling be our floor, and let*
   *us be influencers who create things that will impact _____*
   *_____.*

## Endnotes

1. Rick Joyner, "The Holy Spirit and the Arts," *Morning Star Bulletin* (November 2007).

2. Tamela Baker, "The Lost Arts: Will Christians rediscover the value of creative expression?"; http://thebigpicture. homestead.com/TheLostArts.html; accessed December 21, 2011.

3. "Bob Jones – A new Sword of the Spirit," YouTube video, 3:09, posted by "fr33info4u," (February 1, 2008); http:// www.youtube.com/watch?v=yJKNj7QsIXE&feature=re lated; accessed December 21, 2011.

4. See http://wanderlustproductions.net/ for more information.

5. Daniel Pink, *A Whole New Mind* (New York: Riverhead Books, 2005), 1-2.

6. Ibid., 1-4.

# Developing a Kingdom Creative Culture

There are certain core values that must define a renaissance of Kingdom creativity so it remains pure and has the backing of Heaven. If we move away from these standards, we risk losing the Kingdom aspects that bring God's presence into what we create, producing fruit that will be rotten at the core. We have all bitten into fruit that looked great on the outside, but on the inside is diseased. Without a healthy seed, life cannot grow.

Many of these core values I have learned from the leadership at Bethel Church and have implemented in my life and in the lives of the students in the school whom I have helped to oversee for the last eight years. They also come from my own journey walking with the Lord, ministering, and leading the arts here at Bethel. They are by no means complete, but hopefully will encourage you to develop Kingdom core values that can secure a fresh move of God's presence in all different creative and innovative forms. Of course, it takes time to establish a culture of Kingdom core values, but as we build them through one encounter with one person at a

time, it will shape communities, transform cities, and then move out to infiltrate regions until the whole earth is filled with the glory of God. If we don't have vision for the one, we will miss out on the harvest. It's all about the one that God puts in front of you.

> **Our core values need to come into alignment with our creative identity.**

Here is a story about how our core values need to come into alignment with our creative identity—and the fruit we produce when they do. Aline Lidwell, who attended a prophetic arts conference I was overseeing at Bethel, relates the following testimony:

> I have always been creative, but I have not always valued my creativity. During that conference I had a number of encounters with God where He showed me where I had learned to believe that I wasn't good enough to be an artist, that my intellect was of higher value than my creativity, that being creative was something you did as a hobby, not something to pursue, and that the "creative" stuff I did in ministry was of less value than my ability to teach or lead.
>
> He challenged these beliefs and helped me to see and believe new truths—that I am an artist, that my creative expression is needed and valuable, that I express a part of Him no one else can or ever will, that creative expression is as important to Him as my ability to teach, administrate or lead, that the time we live in requires us to communicate creatively, that He is in this and wants to build Kingdom creativity in His body, and most importantly, that He loves to be with and create with me.

I returned to Scotland with an impartation of creativity and with Theresa's declaration of freedom for me and for Scotland, of a change of season and a release of creativity and especially art. That evening I went to the art class I had signed up for in faith and off the back of a few prophetic words. Up until then, I had not really enjoyed it, was not very good at it, and was ready to quit. I took a postcard of a wave I had picked up in the airport in San Francisco, which captured in an image the prophetic word I had been encouraging myself with for the last few months.

Embracing the freedom I had received at the conference, the joy of creating with God and believing in the impartation I had received, I began to paint. For the first time I felt free to paint without thinking about what the teacher or anyone else thought. I wasn't concerned about making it "perfect," and I was having fun. I was consciously inviting the Holy Spirit to create with me. The difference was obvious. The rest of my class wanted to know what had happened to me! The painting is the first one I can honestly say I've looked at and loved. Up until then I was rarely satisfied with anything I had done. I titled the picture "The Next Wave," and the prophetic word I painted it from was, "I am drawing you back—not to let you go, but to build you up into a bigger wave."

At that point I had no idea that I would ever be back to Bethel, far less that four years on I would have finished three years in the ministry school there and be a part of Theresa's team. I have been privileged to travel with her all over the globe and have seen firsthand how God is touching individuals and nations through the arts.

The story even gets better! In her newfound identity, Aline was released to write and illustrate a children's book about color and creativity:

> The story unravels my journey of discovering how the Creator reveals Himself in His creation—how each color has meaning and points to who He is. It describes how each of us is like one of His unique colors and He needs us to paint with our unique and creative DNA in this world. A bit of Him is missing 'til we display it! The interesting part for me was seeing how the story was, in fact, my story. As I was learning the value of hearing Him, of being in a place of rest, of being filled with love and joy, of being in an encouraging community, and of knowing who I am in Him, I was writing about it. Each of those building blocks created an environment for me to begin to live and be free to create."[1]

## Cultivating His Presence

I myself have had to experience realignment of my core values, as I have shared. I remember the first time I felt God's presence in a tangible form. I was about five years of age and was sitting on the doorstep of my house with my faithful dog, Tammy, waiting for my brothers and sisters to come home from school. The sky was a vibrant blue, and the green leaves were draped like a canopy over our velvet green lawn. All at once, it seemed that time stood still and sound stopped. Something made me look up. The sun gleamed through the leaves of the tree in front of me, and I saw the wind began to rustle the topmost branches, while all the other leaves were completely still. I knew this was God! It was like liquid love came down over me. I knew I was completely loved by God and that He had a destiny for me. I have no idea how long this continued; all I knew was that I was changed.

As I grew into adulthood, however, there were times when I felt conflicted on the road to ministry. I felt that no matter what I did for God, it was never quite good enough. This overshadowed my beliefs about who I was, my ministry, and my creativity. When we are insecure and feel we are not good enough to be valued for who we are, we hide our true identity and begin to value what others think about us. As I did this, I realized that I was coloring inside the lines of other people's expectations, which left my signature out of the picture.

Sometimes you can be lost so long that you don't even realize it until you find your way home. This is what happened to me. I came to Bethel Church and the school of ministry, leaving the beautiful beaches of Southern California and the pastoral ministry I had been involved in for 20 years, and I found *His presence!*

As leaders from Bethel began to share about how God wants to partner with our dreams, explaining that we are not servants, but children of God who freely get everything the Son paid for on the Cross, I realized that they were revealing my place in Christ and that I was finally home.

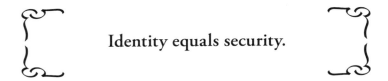

**Identity equals security.**

Discovering my true value has meant more to me than anything else in my life. While attending the school of ministry during my first year at Bethel, all the lies I had believed about my worth, my need to prove myself, and my desire for others to accept me unraveled as I realized that God loves me just the way I am and loves just to be with me. Out of this intimacy flowed the acceptance I needed, and I got my signature back! The little girl who felt God's presence on that doorstep is not letting go of this one thing that transforms everything.

If we are going to pursue developing a creative culture, we must be able to feel God's presence and know that we are sons and daughters of the Most High God, who has given us everything we need. We must let His presence break off any lies about who we are that are keeping us from truly believing this. This is a process that starts by opening ourselves up to Him through encounters in our imaginations. God wants to invade our senses so we can begin to respond to His love by loving Him back with our whole hearts, minds, bodies, souls, and emotions. Loving and being loved by God is not about intellectual assent; it's about encounters in which you literally "feel" loved and it manifests in you and on you. (I encourage you, if you can, to read Bill Johnson's books *Dreaming with God*[2] and *The Supernatural Power of a Transformed Mind*[3] so you can understand God's desire for partnership with you.)

I remember when Beni Johnson first taught us about "soaking" in the School of Ministry. It was a foreign concept to me that you could be refreshed in ministry. I thought it was all about working hard. Spiritual soaking is like stepping into a spiritual Jacuzzi® and letting all of the water and jets make you clean and rejuvenated. Through soaking, you awaken your senses to encounter Him, giving Him space to speak, touch, and invade your spiritual imagination. The junk falls off as you learn to come to Him as a child, listening for His presence. This might sound strange to you, but Christians have actually been practicing spiritual disciplines like soaking for centuries! These spiritual exercises help us become familiar with the spiritual realm, which is where we form a close relationship with God. The great thing about soaking is that there is no right or wrong way. It's just about getting close to Him! Some people fall asleep, others have rich revelation, and others are simply refreshed. It's a way of letting His presence in.

Here are some practical steps for learning to soak. First, put time in your daily schedule to just be saturated in His presence. It could start out as five or ten minutes; the thing that matters is that it is

consistent. Then, get comfortable. You can either turn on soft worship music or have silence; just make sure you won't be interrupted. Now ask God to reveal Himself. You can simply say, "Holy Spirit, come." If negative thoughts about yourself come into your mind, just ask, "Father, what do You think about that?" Listen to what He says. Remember that He is a good Dad who is always speaking kindness and love toward you.

Many times we miss His answer because we are looking for the audible voice of God or a lightning bolt to hit. But sometimes He speaks by putting peace in our hearts, by a still small voice within, by a sound outside, or by bringing a verse to our minds. Just let Him speak in creative ways; after all, He is the Creator of the universe, and English isn't the only language He speaks. Record what He says and follow His lead. Make sure that what you are hearing is biblical and that you are able to confide in others you trust about your journey. I guarantee that if you do this over a three-month period, you won't want to stop.

## Expressing Creativity That Reflects His Nature

*God is good.* This is a theme of our church, which Bill Johnson has championed and which has trickled down into every part of our church culture, much of the city of Redding, and many parts of the world. I believe this is so important because most people think subconsciously that God is *not* good, that He is out to get them, and that He is a hard taskmaster whom they could never please. Thus, though He may be powerful, He won't do anything about the problems in our world, and He stays out of reach. All you have to do is watch television, check on the Web, or talk to people in your community to recognize this general perception. We have to change the way that people think about God, and this will happen as we begin to share that God is in a good mood and that He wants to miraculously intervene through creative expressions.

# Valentines of Love and Healing

As I have mentioned, one of our core values as ministers is that prophecy needs to encourage, strengthen, and comfort (see 1 Cor. 14:3). If we sense trauma, oppression, or other issues in a person's life, we are to come in the opposite spirit, releasing God's goodness. We also believe in the supernatural power of God to heal, so our art teams draw pictures or sing songs over people for healing and see them healed weekly in our community.

One year in early February, Caleb Matthews, a BSSM student, led a team of our students who had all done art pieces for people in the community. Valentine's Day was around the corner, so Caleb had drawn a Valentine's card for a person with a simple inscription about how much God loved that person. The team went to a supermarket, where he was drawn to an elderly woman waiting in line at the bank inside the supermarket. He approached her and asked her how she was doing. She turned and said she couldn't hear what he said because she was profoundly deaf. So he came closer, talked loudly, and turned toward her so she could see the words he mouthed. He told her that he had drawn a Valentine's card for her and asked if she wanted to see it. The white-haired woman smiled and said yes. As she read it, she was so touched that tears came to her eyes. It talked about God being her Valentine!

Caleb saw that she was next in line and asked her if he could pray for her deafness after she made her transaction. She replied, "Oh, honey, they can wait!" Caleb and the team prayed for her, and her ears completely opened! (The bank teller had a chance to see the goodness of God as well.) But the most interesting part of this encounter was the woman's response to the card. She was a Christian, but had never understood that God really loved her. When she saw Caleb's card, this truth became supernatural. She told them that she was so excited that she was healed, but that this was the first time she really knew that God loved her, and she

would keep the card in her Bible as a remembrance. We get to pass out Valentines from God!

## *Honor*

As I have discussed in previous chapters, the way the Persons of the Trinity honor each other is key toward building a Kingdom-minded creative culture. According to John 17, Jesus' chief desire is that we *"may be one as We are one"* (John 17:11). This unity comes about through honor. (One of the fathers of our house, Danny Silk, has championed this core value in his book *Culture of Honor*.[4]) If you want to develop a creative culture for yourself, your home, your business, your church, and your community, you must cultivate honor. All blessings flow from honor and a thankful heart.

Honoring the past reaps dividends for our future.

As we honor wonderful moves of God throughout history, we will receive the fruit from this incredible legacy. Significantly, the Catholic Church wants artists to honor its artistic legacy and once again find true inspiration from God. In November of 2009, Pope Benedict met with artists from around the world in the Sistine Chapel to discuss ways to bring Christ back into the arts. Beneath the vaulted ceiling of the chapel painted by Michelangelo, he told artists,

> Beauty...can become a path toward the transcendent, toward the ultimate Mystery, toward God...Too often... the beauty thrust upon us is illusory and deceitful...it imprisons man within himself and further enslaves him, depriving him of hope and joy.[5]

This means that major denominations feel the heartbeat of Heaven for a new resurgence of the arts being integrated in faith.

Not only are we to honor those who have left a legacy in the arts, but also those who have been forerunners in technology, medicine, business, education, government, and all other places where God's creativity has brought transformation. As we honor those who have gone before, we can receive what they paid for and in turn can develop Kingdom strategies to impact our future. This honor will break the spirit of competition and strife that rules in many spheres of society. If we know that we already have a place of honor, we will stop trying to put others down in order to become greater. Remember, when the disciples argued about who was the greatest, Jesus took a child in His arms and said that whoever welcomed children was the most honorable in His eyes (see Mark 9). This is *so* contrary to how we naturally think, but it is the Kingdom. One of our famous sayings here at Bethel is, "Let *our* ceiling be *your* floor!" We are to help others ride on our shoulders, to honor them, and to pray that they will go farther than we can. We are to bless and honor those who serve and take care of us without the need to be recognized.

One of the ways I train my creative arts teams is by teaching them to honor local businesses and establishments. One Christmas, some of them chose to go to the police departments and fire stations with cookies, prophetic Christmas cards, and Christmas carols. They thanked the men and women for their sacrifice. As they were leaving, they began to prophesy over them. Many were visibly touched because no one had ever done anything like that before.

## Loving Like Jesus

First John 4:16b says, *"God is love. Whoever lives in love lives in God, and God in him"* (NIV). John explains this love further, *"There is no fear in love. But perfect love drives out our fear, because*

*fear has to do with punishment…"* (1 John 4:18 NIV). If we want to develop a culture that lasts, we need to embrace love—love that accepts people just the way they are and then brings transformation. As I equip people to sing, dance, write, paint, cook, and otherwise create out of His presence, they are given permission to enjoy being loved by God. They don't have to get it perfect, be on key, or see anyone healed—they just get to feel loved and accepted. I have people in my classes who weep because they have always felt like they had to be perfect or because they have been criticized for what they created. Perfect love casts out all fear. Once we know that we are loved, everything becomes a joy!

In the process of creativity, we have to know that He loves what we do. No matter what we create, He wants to hang it on His fridge in Heaven, display it to the angels, and rejoice over what we have done because we are His children, and He enjoys us and loves what we do. This changes everything. It doesn't matter if you are a great vocalist, painter, musician, or dancer. If you don't know that He loves it when you create, you will always be looking for approval. Love is the great leveler in the Body of Christ. This doesn't diminish taking time to perfect our skill or craft, but if we start performing, we will end up comparing. If we start with loving His presence, we will end up having greater fruit as we practice and grow in skills.

> **God's presence frees us from performing for approval.**

First John 3:11 also talks about how our love is to become focused outward: *"This is the message you heard from the beginning: We should love one another"* (NIV). It doesn't say to love those who love us or those we are attracted to. It says to love because we have

first been loved. When I train people in creativity, I have them create something for someone else because love isn't love until it is given away. That's how you fall in love—you give a part of yourself away through creativity! It is so fun to watch.

My adult drama group goes out in the marketplace to reach out every week by bringing God's love to others. On one occasion, they decided to ask the Holy Spirit for prophetic acts that would release people's destinies. After they had done a drama in a public place, a woman came up to the drama group to share that she wanted to leave her lesbian relationship and lifestyle because of the conviction she felt through their drama of seeing the power of the Father's love for us. She desperately wanted to follow God, but felt trapped by her lifestyle. The drama team ministered to and counseled her, encouraging her with testimonies, but mostly shared about His love. The presence of God began to melt away the ice around her heart, and she began to weep. That night, she decided to give her life over to Jesus! The Father wants to get His kids back, and drama can be visible, tangible demonstrations of His love that cross lifestyle barriers and false religious hang-ups.

God's love is looking for human targets. We become that target by receiving His love and learning to create in His presence. Then we use our creativity to send His love like arrows into the hearts of others.

## Community in the Church and in the Marketplace

One of my strongest core values is that nothing is sustainable or replicable unless there is community. Again, Jesus is our model. In order to transform the entire world, He hung out with 12 men for three years. Of course, He didn't just hang out alone with them; He gave them His vision for the world and initiated them into His way of doing things. He always sent them out in pairs to minister.

He went to all kinds of parties, and He loved weddings. In light of this, look at how Christianity has spread and how community and small groups are the way cultural transformation can be passed from one generation to the next. I like the way God thinks. He is tribal. He doesn't care about squabbles, petty indifferences, or personality clashes. He really wants us to be a great big family and to work it out. He really doesn't mind if the people in the community are drunk, dirty, homosexual, living together, poor, or rich. He wants us to love them all.

This core value for community starts with leadership in the Body of Christ. I see this modeled at Bethel in the relationships among the core leaders, who have been together for the last 20-30 years. They sustain revival as they work together in community. I myself grew up in a charismatic community and believe in its value. I always travel with a team because I want the different churches where I minister to know that it's not about one person being anointed; it's about building a community. I let my team share, demonstrate, and give testimonies about supernatural creativity because I want them to know that it is transferrable and doesn't just flow from the speaker. I send people out into the marketplace in teams as well. This way they learn to work together and discover that when one is weak, the other is strong.

Garrett Viggers, a musician and worship leader in Redding and a friend of mine, has a similar desire to see Kingdom creativity in the marketplace. He arranges for local bands from various churches to come down to a local coffee shop on Friday and Saturday nights and play while artists, sculptors, and designers create. Garrett and I meet to discuss how we can impact the city through creative ways. Our desire is to build a creative community outside the four walls of the Church where everyone gets to feel God's presence through creative expressions!

I also believe in accountability and honoring leadership at each church. When I travel, I minister creatively to church staff. If you want to build a community of creative people where creativity is transferable, it is just as important to be under the leadership of the church you attend as it is to work as a team.

## The Power of RISK and Being Spirit-Led

I enjoy watching Jesus with His disciples. Every time they got comfortable, He would rock their boat—sometimes literally! Once they wanted to send the crowd home to get food. There were only five loaves and two fish to feed 5,000 men, not to mention women and children (see Matt. 14:13-21). Jesus showed them the dynamic of another Kingdom, prayed, and gave thanks. But though thanks-giving began the miracle, it didn't materialize until it was in the hands of the disciples. Miracles happen through divine partner-ship and trust. Later the disciples were on a boat without Jesus when a storm kicked up. Jesus came walking to them on the water, and the disciples all worshipped Him, saying truly Jesus is God's Son. Supernatural power opens eyes to see who Jesus truly is. Je-sus' whole purpose in these events, and in His life, was to empower the disciples to walk in the fullness of their identity as He reveals who He is. Again, He wants us to perform even greater miracles than He did.

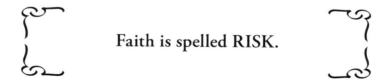

**Faith is spelled RISK.**

I believe the only way we can grow into our identity is through risk and trusting the Holy Spirit. In May of 2011, Bill Johnson spoke in the School of Supernatural Ministry and said that creative miracles will happen when creative sons and daughter begin to cre-

ate. Why is this? I believe it is because we have to "see" the greater glory before it is released. Art, songs, writings, fashion, music, and dance have the capacity to usher in the supernatural, unseen realm of the miraculous. For example, a woman from England began to be healed of anorexia after looking at a prophetic art picture drawn by a child. A little boy gave her a picture and explained that it was about strength. She was wonderfully touched and fell on the floor as God's presence overwhelmed her physical body and ministered to her spirit and soul. She is now putting on weight and looks at her life very differently.

Once I was painting during a healing conference at Bethel, and I wanted to release the leaves of healing for the nations (see Rev. 22:2), so I drew a tree from Heaven's perspective. A woman named Sallie Smith bought the painting. She then emailed me about how a miracle was released through this painting as she took a risk:

> I took your painting to our meeting and shared with the group what the Lord was saying to me through this paint- ing. Marc [her husband] opened the meeting by having us all ask the Lord what He wanted to do and encouraged everyone to chime in with what they felt Holy Spirit was saying. Just then, the outside of my left ankle started to hurt. So I shared that and a young man said that his left ankle was messed up and hurt on the outside! So Marc stopped everything and had us all gather around him to pray. After a bit I had him move it—it was better but still sore, so we prayed some more...and it was completely healed! Theresa, this had never happened to me before, where I would feel pain in the part of my body that the Lord was highlighting! The leaves of God's healing are indeed for us! Your painting stands as a "milepost" for me and a reminder to our group that the Lord is about His work and wants to use us!

When we take risks, God shows up and moves in and through us. I ask my students who go out weekly to release creativity and ask the Holy Spirit what He wants them to do. One person received the same Scripture I had received from Revelation 22:2 and felt the Holy Spirit wanted them to go outside and find leaves to anoint. The group went out with the leaves and asked a man they met if he needed healing. He said that his foot was in continual pain. The girl who had anointed the leaves shared the Scripture and what God had shown her. Before she had even given him the leaves, all of the pain left his foot! They looked down, asking him to move it around to confirm the healing and saw that a leaf had fallen on the healed foot! No matter how hard he tried to get the leaf off by shaking, it clung to his shoe. He stomped his foot, jumped around, and was completely healed. The next day someone saw him walking around town with the leaf tucked in his laces, a visual reminder that Holy Spirit-led risk and creativity transform culture.

Some people ask me, "Why would God do this?" I believe it is because God loves us and wants to astound us with the creative ways we can partner with Him to see transformation. God is always looking for people who will take a risk with Him, release the supernatural, and bless others creatively—even through leaves! It's time we looked at impossibilities as one risk away from being realities. God is asking us, "Who wants to dream with Me?"

## Creative Destiny, Character, and Stewardship

Sometimes we forget who we are. All you have to do is watch a child with a box of crayons or building a house or car with Legos to see that they *know* they are creative. Who told us we were not creative? It wasn't God! We are made in His image, and every thought that negates this has to be obliterated. God's creativity can take many forms, but the bottom line is that it is a part of our nature that needs to be explored, excavated, and released. I have the privilege of

awakening this in other people all over the world and it is so much fun! I know that if they can have success in creating something in God's presence, then they can apply this in whatever sphere or ability in which they operate.

**Creativity is no respector of persons.**

I speak every year at Randy Clark's School of Ministry in Harrisburg, Pennsylvania. As I teach the students, I can often tell that some of them are skeptical of supernatural creativity. Some of them have this look of sheer terror, as if to say, "You are asking me to *create?* You must be out of your mind! I came here to learn how to contend for healing!" But then, as they begin to create art pieces, sing prophetic songs, and see people get healed through creativity, their eyes shift from skepticism to wonder.

I usually instruct the students to draw a picture or write something to give away to someone outside of the school. One student was extremely doubtful and decided to go home and not give his art piece away. Instead, he went to visit a friend who was depressed. He had tried for hours to get through to this friend, but couldn't. All of a sudden, he remembered his art piece in the car. He thought he would try giving his art piece to the man, since nothing else had worked, not truly believing it would make any difference. As he began to explain what he had drawn, he realized the significance of what he had randomly drawn. There was a light breaking into the darkness. As he began to share about his picture, his inconsolable friend broke down and received prayer—asking for God's help for the first time in months! The student came back to class the next day and said he had seen the light, in more ways the one! He now has the power to ask the Holy Spirit for creative ways he can reach people because *He is creative!*

Another core value necessary in building a creative culture is character and faithfulness. If we are going to have a creative community, we must develop people who will be faithful with the tasks they have been given and steward their gifts with excellence. At Bethel, we want to develop people who know they can create, but also those who are gifted in certain areas and can develop their gifts and talents both supernaturally and through practice. I have gathered artisans in an apprenticeship who meet weekly to be trained, build family, and touch our church and city through excellence in the arts. We have brought in people from Hollywood to help train our dramatic community and to bring excellence to our craft. First comes His presence and then comes anointed excellence!

## The Power of the Testimony

At Bethel, we eat, breathe, and sleep testimonies because we know that, if God did it once, He can do it again. Testimonies create a lifestyle of celebrating God's miracles among the living, and this has power to shift the culture. Testimonies lead us to what God is currently doing and set the bar for greater increase. We don't want yesterday's manna; we want to feast on what is happening today all over the world. This is the power of the Good News! People flock to Jesus when they hear testimonies. This is so key in building a creative culture because God never does anything the same—so as you release supernatural testimonies, you are releasing people to think outside the box of life as normal. If you want to see creative expressions released at your church or in your area, begin to share testimonies and then begin to pursue greater miracles through compassion and risk! Revelation 12:11 sums up the power of the testimony in our day:

> They overcame him by the blood of the Lamb and by the word of their testimony; they did not love their lives so much as to shrink back from death (NIV).

The Christian life boils down to this: Jesus' sacrifice, the fruit of our testimony, and risk! Let's find out what matters most through living for what matters eternally!

## Understanding Core Values

*Take time and let God love you as you soak and create in His presence! Write down what He shows you.*

_____

_____

_____

_____

*Which core values mentioned in this chapter do you feel are central to you, and how can you incorporate them so they become part of your lifestyle?*

_____

_____

_____

_____

*Take a risk and partner with the Holy Spirit to release a creative expression for someone and go after healing or the prophetic. Remember to start with the one!*

_____

_____

_____

_____

*What other core values would you add that are important to you in developing a creative culture?*

_____

_____

_____

_____

*How can you steward your creative call so that it becomes supernatural and excellent?*

_____

_____

_____

_____

# Endnotes

1. Aline Lidwell, *What Could We Paint with You?* (London: Esteem World Publications, 2009), 1-45.

2. Bill Johnson, *Dreaming with God* (Shippensburg, PA: Destiny Image, 2006).

3. Bill Johnson, *The Supernatural Power of a Transformed Mind* (Shippensburg, PA: Destiny Image, 2005).

4. Danny Silk, *Culture of Honor* (Shippensburg, PA: Destiny Image, 2009).

5. "Pope meets artists in the Sistine Chapel," *Catholic News Service;* http://cnsblog.wordpress.com/2009/11/21/pope -meets-artists-in-the-sistine-chapel/; accessed December 21, 2011.

# Supernaturally Supersize Your Life!

Now that we have discussed our creative destiny, God's nature, and the core values for developing a supernatural culture, we can have fun exploring the different ways that creativity can bring celebration. One of my favorite things to do is to show churches how to use creativity to bring life to their congregations and communities. This is so important because Jesus wants us to be filled with joy and to release joy and celebration because of His finished work. In the Old Testament, they knew how to throw a party! They had festivals, got together to celebrate victories, and memorialized events in Jewish history like the Passover. These usually included singing, feasting, the making of goods, and dancing. God wants to bring back celebration to the Body of Christ through the arts!

If we are honest, most people don't think of Christians as having fun or enjoying life because this hasn't been their experience. But this is changing! We are beginning to understand the significance of building community and celebration through creativity. Take the

Jesus Culture movement, for example, which Banning Liebscher started at Bethel in 1999. The passionate music of this movement has drawn people back to God in countless cities and nations. Jesus Culture states that the purpose of music in their movement is to *"ignite revival in the nations of the earth...compel the Body of Christ to radically abandon itself to a lifestyle of worship, motivated by a passion to see God receive the glory that is due His name..."* and to *"encounter His extravagant love and raw power."*[1] These times of celebration are growing rapidly. The 2011 event in Chicago's Allstate Arena drew 14,800 hungry revivalists![2] I have been to these gatherings and can attest that passionate worship is giving youth an experience in the Holy Spirit that will be remembered in history. They are turning the tide through passionate music that leads to *encountering God!* This is the power of supernatural creativity that will bring revival!

## Big Gulps on the House!

When I put on a four-day event called the School of Supernatural Creativity in May of 2011, I wanted people to hear great, prophetically gifted speakers who believe in the supernatural. We had 18 different workshops to appeal to different people's interests and passions, all demonstrating how to develop various crafts and creative expressions supernaturally. Then, during the breaks for lunch and dinner, I activated my massive team to demonstrate how to prophesy and heal others through creative expressions. I had testimony and evaluation forms for people to fill out, and I found out through these that what they commented on the most was the activation times during the breaks. They weren't just hearing about creativity; they were experiencing its power firsthand!

In this chapter, I am going to highlight the different creative expressions that we demonstrated to people during the breaks. These are expressions that we use in the marketplace and in church. I will include testimonies about these different creative expressions. As you read through these pages, please feel free to

take these strategies and develop them. Highlight the ones that are intriguing to you, and at the end of this chapter, begin to put together your dreams for transforming others through your creative expressions![3]

## Culinary Arts: "If You Give a Revivalist a Cookie..."

I know that everyone is excited about this creative expression: food! Wait, you can prophesy through food and see people get healed? Yes. Food not only invites our senses to encounter God's goodness, but it can also be a way to prophesy life to others. I know all the chefs out there will love it! The basic concept is that you can ask the Holy Spirit for a recipe or a prophetic word that goes along with the food you prepare. This is also powerful because you anoint the food with your hands and with love! Here are some helpful steps:

- Step 1: Ask Holy Spirit for a person or group who needs healing or a positive encouraging word.

- Step 2: Begin to make what God shows you and continue to let the Holy Spirit fill you. See that person getting better or being touched by God's presence as you prepare the food.

- Step 3: Ask the Holy Spirit the best way to present it. Prophetic cooking is about presentation and finding the right place and ambiance.

- Step 4: Invite the person or group over, share with them what you have made, and give your delicious gift away.

- Step 5: Always ask for feedback about what it means to them. Write down the testimonies and begin the process of stewarding this gift and call.

At the School of Creativity's culinary arts booth, they prophesied over others through cookies with a prophetic message of encouragement inside. They offered soothing tea for healing and made prophetic pizzas. After one person heard about the ingredients in the food, she realized she could make this for her family and serve up supernatural love every day. As one person drank tea, the raspiness in his throat left. While eating a prophetic cookie, another person's eyes were opened to see the parallel between what is going on in the natural and the spiritual. She saw the banqueting table as a place where people could dine before the King of kings. A chef who had come to the School of Creativity the previous year came again, and this time he helped teach a workshop. He is moving here to open up a prophetic pastry shop. My husband is excited about that one—everyone gets to benefit from prophetic culinary arts!

## Spinning Dance Brings Freedom

Dance changes the atmosphere, brings healing, and builds a community spirit. Prophetic dance embodies movements and aspects of the invisible world. Whether you are accomplished in dance or have a desire to move in worship, this is a way of bringing freedom and His presence everywhere you go!

Here are some practical tips for you with dance:

- Step 1: It is important to know your body and how to protect it, so make sure you stretch and warm up. Also be aware of appropriate clothing, making sure your bra strap, underwear, boxers, and stomach are covered.

- Step 2: Practice dancing at home, and then begin to dance over people, hearing from the Holy Spirit. When I travel, one of my students comes up to the front and calls out a person to dance over. Then the student gives the interpretation and the person is free to share what it

means to him or her. (By the way, all different kinds of dancing styles can be anointed. I saw a lady who couldn't dance because of crippling arthritis get healed as a break-dancer ministered through dance. He danced, and then she began to dance with him, copying his moves, which was exciting as she was around 60 years old! )

- Step 3: If you are hosting a booth at an event, have a company of artists in a designated place who can take turns dancing over people. Be aware of music needs within the area and the need for additional space.

I know that a lot of dancers out there may be nervous. "What? This isn't choreographed? How do you know what to do?" This is where you rely upon the Holy Spirit and become childlike. This is such a powerful tool for freedom. At the School of Creativity, one person learned to dance by what the Holy Spirit showed her, and as she danced, she became free from the fear of people. When I use the phrase *dance over,* I mean that we actually dance as the Spirit shows us while the person for whom the dance is intended watches. We then ask that person what happened, finding out how God was moving through the dance and how the person was impacted spiritually, physically, or emotionally.

One time, a person who was danced over had wobbly ankles and had been in pain for 20 years. As someone danced over this person, all of the pain left and the ankles returned to normal. Another person had previously felt gripped by fear whenever she danced. However, when she danced with one of my interns, Annabelle Lee, spinning wildly in abandonment, all of the fear left, the weight lifted off, and she felt free!

## Drama Improv Brings Double Anointing!

Drama and film are such a huge part of our culture. Sometimes we think that we have to start with a script and work for hours on

memorization for it to be anointed. But I have found that if we are excellent at characterization or have a passion for drama, improv can be a great tool for the supernatural. At the School of Creativity, I gathered a drama team together, put them in pairs, and assigned them to play certain characters. They then were to engage people on what they had been learning at the school. We had characters like Annie Oakley and a stoic philosopher roaming around during the breaks!

Here are some helpful suggestions for supernatural drama:

- Step 1: Decide who your audience is and the type of drama you want to use. You can do one for children, a video, improv, short skit, or full-length production.

- Step 2: Gather the cast, present the vision, and begin to rehearse. If you are performing improv, choose your characters.

- Step 3: Pray and ask the Holy Spirit to come.

- Step 4: Practice, practice, practice.

- Step 5: In improv, I want the characters to engage people and, if possible, go after healing or prophetic destiny. If you plan on doing another type of drama, make sure you are prepared at the end. A drama leads people to truth, so what do you want them to do with that truth? What would be appropriate in that setting? Incorporate the freedom you have in sharing more intimately through testimonies or through a salvation message tailored to your audience and your vision for that event. We also had planned and rehearsed dramas that we did after worship during the conference, which gave people a visual of our theme and set them free from religious mindsets. There are many ways that drama can be impactful and can radically bring the supernatural power of God through us.

Here is another testimony from the drama improv group. During the school, one of the groups prayed for a person who had had a toe injury for 20 years, and the toe was healed! Then the group had the person who was just healed pray for another person's injured toe, and it was also healed! Another drama group prayed for a person who was having a severe migraine, and she was healed and received an impartation. Later that day, she prayed for another person who suffered from migraines, and that person was instantly healed. God is good! They had double anointing and double fruit off the vine.

## Destiny and Healing Art Cards Heal Elbows

Everyone usually enjoys receiving cards for birthdays, Christmas, and other special occasions just as I do. A supernatural art card is a pictorial representation of what you see in the Spirit over a person, and it usually requires an interpretation. The drawing can be simple and sometimes may not make sense at the time. You just have to focus on the person, let the core value of compassion flow from God's presence, and then create. You can use any type of paints or dry media, like colored pencils, that you like. I know some people who use photography in their cards, asking Holy Spirit what picture represents a person and then writing an interpretation. You can buy blank cardstock with envelopes in large quantities at a craft store, but anything you have will do. Those who are very gifted at art and those who are just starting out can make destiny cards.

Here are some easy tips on how the process works:

- Step 1: Pray and fill up in His presence. If you know the person you are drawing for, you can begin to pray for that person. If you are in a booth and the person approaches you, introduce yourself, make the person feel comfortable, and ask how he or she is doing. Also, find out if he or she is sick or needs healing in the course of your conversation.

- Step 2: Ask the Holy Spirit what He wants to do, and then begin to create!

- Step 3: Write an interpretation inside, and then give it to the person.

- Step 4: Ask him or her what it means. Follow up with healing or prophetic ministry if possible.

Here are some testimonies from the school. One person said, "Someone drew a picture of pain in the elbow, and when I touched it, I was healed. I then had someone else touch it who had elbow pain, and that person was healed, too!" Another person on my team gave a business owner an idea for his logo by the card created for him, which he felt would have a supernatural impact.

## Singing Telegrams Bring Hope

Have you ever had a song stuck in your head? What about when you hear a song and it brings back memories of a particular time in your life? Music is powerful because it is attached to emotions, relationships, and memories. Many of the Psalms were sung because it was a way of easily remembering the past victories of God. Imagine what would happen if we partnered with the Creator to create music that would bring healing or call out people's destinies? As you learn to prophesy through song, you will see radical miracles happen.

Here are the basic steps in prophesying to someone through song:

- Step 1: You can have two or three singers "tag team" until you get more comfortable, or you can do it one-on-one. It's all about hearing from the Holy Spirit. Ask God what He wants to say to a person. It doesn't need a verse, chorus, and second verse—just sing the word God gives you. If none of it repeats, that's OK because it's your song. Music in the background can help, but this is not a

requirement. You can prophetically sing over a church, a group of people, or one person.

- Step 2: After you sing, explain what you felt as you were singing and ask the person or people what it meant to them.
- Step 3: Make sure that you pray for the people if they are touched. Music awakens people and lets them know that God loves them enough to have a special song just for them!

I know that singing is one of people's greatest fears. But I believe that wherever fear rears its ugly head, you are to step out, risk, and take dominion. Here are some testimonies to give you the courage to start:

Through a prophetic song, God encouraged me to let go of disappointments and receive hope.

As they sang over me, I realized that God is writing a song about single moms like me. I am going to now write my story as a song!

I was nervous to sing over people, but every time I did, they confirmed the song was from God. I was so encouraged!

## Music Reveals Encounters with the Father

As we have traveled, my husband, Kevin, and I have seen instruments played over congregations, multiple times, with powerful results. Many people have been healed without anyone laying hands on them, just as Saul experienced relief from demonic torment when David playing his instrument. At the School of Creativity, we had a group of musicians play over people with violins,

guitars, or other instruments and release God's presence over them, with powerful results.

Let's look at some practical steps:

- Step 1: Practice playing your instrument alone, and get used to feeling His presence as you play. As you grow, think about someone who needs a touch from God, and start to play whatever the Holy Spirit shows you. This is the way you practice.

- Step 2: Then, as you grow in confidence, take the next step, and find someone to play a prophetic song over. Share with that person what you feel it is releasing.

- Step 3: Ask the person what it means. If the person needed healing, find out if the person now feels better. If the person needed encouragement, find out what is happening inside of the person. As you do this, begin to identify the language of the Spirit. You can play music prophetically without anyone even knowing it!

Musicians, it is time for you to learn to release the song of the Lord over people, churches, regions, and countries. Trust what the Holy Spirit is doing, and go for new sounds and new ways of playing! At the school, one person received partial healing from a neck and shoulder injury, then went over to receive an instrumental song, and was completely healed! As a musician played the saxophone over another, the person was taken on an encounter of joy with the Father. A person who had a suppressed calling to minister in the marketplace in Seattle received breakthrough to go for his dreams.

## Legacy Writers Affirm Call

Writing supernaturally can unlock people's identities and radically transform them. On one of my trips to the San Francisco Bay

area, I asked Anna Elkins to write a prophetic poem. Here is her testimony:

> This was my first official prophetic poem, and I wasn't sure how to go about it. I had the overwhelming sense of the word "pearl" as I entered the church building. I wrote a quick poem about a pearl—not just about its formation, but also about how it is strung with other pearls to form a necklace that turned trial to beauty and strength. I knew I was to ask if anyone was wearing pearls. When handed the microphone, I asked if anyone was wearing pearls. Several came forward, and as I read, one of them started weeping. She told me her story. She had endured a very difficult childhood and had created a ministry for women with the word "pearl" in the name. She was wearing the pearl she had been given when she had launched the ministry. Her goal was to unite women who had been abused and to help them see their beauty and unity, just like a pearl necklace.

Let's talk about how you can get started prophetically writing for others:

Step 1: Put some thought into how you will present your writing. Often you will simply read it to the person, but when he or she hears it, the person will want a copy. Be prepared and bring one.

Step 2: Take some blank cards to write on, colored pens, and anything else useful.

Step 3: Engage the person and have him or her sit down. If you are doing it for someone you will meet, begin to ask the Holy Spirit for what you are to write.

Step 4. Start to write, but make sure that you are blessing the person as you write.

Step 5: Read it to the person and ask what it means. Engage the person to see if he or she is touched and if you can pray for him or her or see him or her healed through this piece.

Here are some other creative ways that may inspire you as you write. You can write a recipe of what God has put in people, an acrostic using their name, or a story about them. You can paint a picture or vision with your words or write a love letter from God to them. Many times you can have them write something themselves as they wait for their writing piece.

Here are some testimonies from the school:

I had someone read my writing over me, which revealed my need to repent, as I did not believe what I had written. I was then able to hear and receive these words of affirmation that are a love letter from God.

Here is another testimony about breakthrough in destiny:

The process of writing affirmed my call as a counselor and brought confidence in my ability to do so that many qualifications never did. I am free and now know to co-labor with God in my work.

## Supersizing Vision

I am so moved by how God can transform lives as we create. It was incredible to me that just four days of releasing creativity to the attendees at the school were so life-changing. The testimonies I have shared with you are just a handful out of so many we received. This was able to happen through a culture where people were trained in supernatural creativity. Miracles explode when you let His love leak out in creativity on others.

One of my favorite testimonies during the school was from a medical doctor in Hong Kong who had suffered with depression

and anxiety for 15 years. During lunch, children from Bethel Christian School joined our team to draw prophetic pictures for people. One of these children drew pink blossoms and wrote the words, "Bloom for Jesus," for this doctor, explaining that God was going to plant and water her. She then visited every station that we had with culinary arts, writing, song, dance, and music. After this, she was completely healed of depression and plans to introduce prophetic art into the hospital ministry, marketplace, and community of Hong Kong. In so many different cultures, the arts can get into places that preaching cannot.

Another person who came to our school of creativity last year was suicidal, and through the speakers and the school, she repented and turned her whole life around. Then she went home and became involved in the arts ministry, helping others who are depressed find freedom in Jesus through the arts!

## "See One, Do One, Teach One"

Jesus used this principle in teaching His disciples a supernatural lifestyle. First, they saw Him heal the sick. Then they went out by two, and His mantle was passed to them. After Jesus ascended, the disciples began training others to walk in healing and the supernatural. This is the philosophy that doctors follow when they are learning to practice medicine. I believe this is the way most people become secure in supernatural creativity as well.

At the School of Creativity, we added events during the break times where participants could paint something during a live worship set. We called this activation "Encounter Art." People came in and were prepped on how to paint freely as the music was playing and people were singing prophetically. They had been learning to "see" as my team and I taught and shared testimonies about supernatural art. Now, they were going to "do" supernatural art. During

this time, it was very important to make people feel comfortable, as many were taking a big risk. The impact was stunning!

Many people were set free from fear as they created during the Encounter Art sessions: "For the first, I felt accepted in my art and heard God say that I could just 'go for it.' I am calling the painting *Freedom.*" Another person said, "As I painted, I felt a release from performance and control. I saw Jesus lifting and spinning me about. This revelation brought freedom." Other people were healed: "A word of knowledge was released with a painting in the Encounter Arts, and a person's neck was healed while touching it." Another person had a degenerative disc disorder and was healed while painting. People were healed emotionally as well: "I discovered freedom as I painted and felt like I was dancing with the Father. He spoke personally to me that His thoughts of me were like the grains of sand." These people were transformed through the process of creativity! They didn't just hear a speaker or receive a creative expression; they entered into the process themselves.

There was another room set up where people could bring their artwork in to be critiqued by accomplished artists with a prophetic viewpoint. There was always a line for these critiques because there has really been no place where creative people can go to work on their craft as well as hear encouragement through prophetic ministry. Here is a testimony from the art critique: "I kept wondering if I should continue pursuing my art. Having my work critiqued and hearing that it does bring Heaven to earth has changed all of that. My encounters with God here have changed me." People need to know that what they create is valuable and that God can use it to transform lives at whatever level of mastery they currently have in their craft.

During this school, I also had get-togethers with those engaged in prophetic arts in their church and communities because I wanted them to be able to raise up creative communities. My team,

which was largely comprised of students in the Kingdom Creativity Track in the School of Ministry, were involved in my "teach one" model, and many are presently teaching about creativity around the world. For me, this means that I have been successful in reproducing a culture that will continue to raise up supernaturally creative people. Nothing makes me happier than to receive reports from others I have raised up about what they are doing in another part of the world!

Kristen D'Arpa, who was my intern in 2010, is now leading creative conferences on the East Coast. Here is a report from her about what happened during her most recent creativity conference:

One of our team members got a word of knowledge that the Lord wanted to heal sinuses and lungs. She drew pictures of a nose and a set of lungs and called for those in the service to come up if that applied to them. A woman came who had a deviated septum in her nose and had been unable to breath for quite some time. As they prayed together, our team member asked her if she needed to forgive anyone. She listed several people and, after they prayed through to forgive each one, the woman was able to breath completely normally!

Another woman came up for prayer in response to the word about lungs. She had emphysema and several other issues which meant she could inhale but had difficulty exhaling. The team member had the woman hold the picture to her chest and, as she did, she felt light breaking forth inside her. She started breathing very quickly and found that she was able to exhale normally! She took the dance workshop the next morning and couldn't stop dancing all day long. She gave testimony of her complete healing, released healing for others, and even danced a

prophetic dance for and over the congregation at our last service.

## Now It's Your Turn

Seemingly simple acts of creativity make sense when you understand how the loaves and fish were multiplied through the disciples. We must understand that God has been longing for us to partner with Him so that His people can be given what they need. The miracle will happen through your hands, as you believe. Ask the Holy Spirit what He wants to do and begin to "do" now that you have "seen" through the lens of the testimonies.

## Supernatural Creativity Exercise

*1. Get alone with Jesus and just let His presence come upon you!*

*2. Ask the Holy Spirit to show you what He loves about what you create.*

*3. Now ask Him what person, who you are able to visibly see or visit, needs a touch from God today. It could be a friend, a relative, a person at the grocery store, or someone who is sick or needs encouragement.*

*4. Now ask the Holy Spirit what type of creative expression would really bless this person. Do not ask for the easiest one, but for the one that would bless that person. You are learning to move out of compassion, not comfort.*

*5. Now begin to create whatever He shows you. I always have people ask the Holy Spirit at the end of this time if there is anything else that would be important to add, so make sure you do this!*

*6. You **are** creative, so make sure you sign your writing, artwork, song, or recipe if it is possible. I know that some creations you can't necessarily sign, but you could put a tag on it. Try your best.*

7. Now go give it away, making sure that you share the interpretation with the person, and then always ask what it means to the person.

8. If you have never seen anyone healed, pursue this. Ask, "Do you have any sickness in your body?" If the person says yes and allows you to pray, all you have to do is command the body to be healed in Jesus' name. Just say a short prayer, believing that God always comes when we pray. Then have the person check it out to see if it is better. Have the person try to do something that was impossible before. You will be surprised by how many people Jesus heals.

9. Write down the testimony! This is how you see progress and bless others so that God can do it again.

*10. Lastly, thank God for what He has done and how He has used you. The more adept and confident you become by taking risks and activating yourself, the more He will open up doors for you to train others so that God can get His full reward.*

# Endnotes

1. "About Us," *Jesus Culture;* http://www.jesusculture.com/about; accessed December 21, 2011.

2. I received this number from Jerry Niswinder, one of the Jesus Culture leaders who was at the Chicago event.

3. Almost all of the testimonies used come by permission from testimony forms of attendees' of Bethel's School of Supernatural Creativity, May 24-27, 2011, at Bethel Church in Redding, California.

# Releasing Supernatural Creativity in the Church

We are seeing an explosion of creativity at Bethel Church. Many members of our pastoral team have written or are writing books. Our media department is starting to produce films of increasing excellence. New albums by Bethel musicians are coming out in multiple genres. Artists are selling their art all over town and after services on Sundays. Our dance team has many people who have performed professionally and are now pursuing a career in dance. This is not only impacting gifted people, but it also has infiltrated the different ministries within our church and is affecting the way people do life and ministry in countless ways.

Supernatural creativity opens people's eyes to who God is, to the many ways He can speak to and through them, and to the ways He will move to bring healing and transformation. It also drafts everyone into creative partnership with the Holy Spirit, breaking off the mindset that we have to have a degree to hear from God or make art. At Bethel, we have developed a culture where all people get to

prophesy and walk in their supernatural destiny through creative-
ly partnering with God. We equip people to understand the basic
principles of an encouraging culture where love, honor, and encour-
agement are the bedrock for all prophesy, but we also believe that
people are on a learning curve. If people risk, we know that at times
they will not always be 100 percent accurate. This is why we pref-
ace what we say by, "I believe the Lord is saying..." or "I could be
wrong..." or "Does that mean anything to you?"

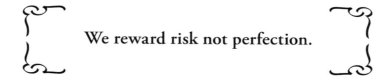

**We reward risk not perfection.**

We are not the Holy Spirit, and we are in training; therefore, it
takes the pressure off of the misconception that we have to be perfect
*before* we even try. Imagine saying to your one-year-old child, "Take
a step, but if you don't get it right, you can never try walking again."
We would think this was crazy! Yet many Christians are so fearful
of prophesying that they never venture forth to learn. We feel the
same way about learning how to create. There is room for those who
are talented to grow in excellence and anointing, and there is room
for those who desire to creatively express themselves supernaturally
in the Body of Christ.

The creative focus at Bethel was specifically released at Bethel
in 1998 when senior pastors Bill and Beni Johnson gave Renee Coo-
per the green light to start an arts and intercession ministry during
worship on Sunday nights. She was hungry to combine color and
movement with the sound of worship in such a way that would in-
tercede and call artists back to the church. Dance and flags eventu-
ally became part of Sunday night worship. As the Holy Spirit was
released to move creatively, other doors began to open. Students
in the School of Ministry were given the opportunity to minister

through art media. When I came on staff in 2003, we began to release creativity prophetically in the marketplace and saw healings and supernatural ministry take place in a non-Christian setting. This journey of many small steps toward the same goal has built a structure in which every church ministry at Bethel knows the power of supernatural creativity and partnering with the Holy Spirit. My hope in sharing what we have done at Bethel is to help you cultivate His presence and release it creatively. I hope it gives you ideas about what is possible in your local church, home group, or ministry.

## Children

Did you know that children could be taught to prophesy and heal the sick? As children are taught who God is and how to listen to His voice, they create things that transform people's lives. After all, there is no "junior" Holy Spirit. We need to cultivate faith in our children so they can hear from God and experience the miraculous, laying the foundation for their history with God. At Bethel, children are taught to ask God what He is saying and then to express what they hear in dance, singing, drawing, and writing. Children now paint during worship with the adults, sharing a canvas between several children and a pastor.

Our children's pastor, Seth Dahl, is pioneering ways for children to grow creatively. After the 2010 earthquake in Haiti, I asked Seth if the children in Sunday School class could draw pictures for the people of Haiti. They asked the Holy Spirit what message the people needed to hear to restore faith and hope back to their families and to the land. Then they all drew what they saw. My husband, Kevin, led a team from Bethel to help with the relief efforts in Haiti and passed these pictures out to the devastated survivors. He said that this brought more joy and hope to the people than anything else they gave away. This is the power of our children walking in their destinies. They can transform nations with hope!

Children ministered to me in December of 2006, when I fell on ice and literally cracked my head open from one end to the other. I was in the hospital and had to undergo brain surgery, unsure of what the outcome would be. The children's department, ages two to five, made a blanket with prophetic pictures and words to release healing for me. I put the blanket on my body, experienced healing, and was back to work three weeks later, which was a miracle! This is the power of healing that happens through children—even if they are not present!

At Bethel, I have taught children's classes on the arts and have seen children of all ages hear from God and create! My manual, *Cultivating Kingdom Creativity,* has lesson plans for children at the back of each chapter to teach them to prophesy and see healing happen through singing, dancing, art, writing, and much more![1]

## Youth

As I shared earlier, music greatly impacts youth who are crying out for identity and community. Churches that are culturally relevant in worship and that release the supernatural, will draw youth to come. At Bethel, this is one of the key ways that God moves upon the youth, along with painting during worship and skits that bring Kingdom messages to life. God wants to move supernaturally through different creative expressions in worship, where the youth are able to visibly and audibly perceive a new sound that opens His presence to them in ways that bring identity and transformation.

I once ministered at a church in northern California that was located in a neighborhood where a lot of street and gang youth hang out. Some of them were hanging around outside the church building, so my team and I invited them to join us at the meeting where I was about to speak. They definitely looked uncomfortable, but they were intrigued by our smiles and the way we approached them as we commented on their tattoos and skateboards. I knew the pews were

totally foreign to them, so with the pastor's permission, I asked them to come up front at the altar and do some tagging on paper. (Tagging is the act of performing simple graffiti using spray-paint to mark one's territory.) They seemed excited by the idea. I got a ream of paper and some markers and pens, and I placed them around where they were sitting. All through worship, they sat on the ground, fully engaged in their artwork.

After announcements, I had my team members who had painted on stage display their artwork. I could tell these pieces were not in these kids' genre, but still were totally different than what they thought was typical in a church setting. I then invited some of the skater youth to share about what they had drawn. They had drawn symbols representing God and what they were experiencing. I hung them up around the front of the church for the people to see. As I spoke that night, these kids were riveted. Someone from a church had recognized value in what they had created and given them a place in church. That night, many gave their lives to Christ. They got involved in the life of that church and were radically touched. One of them came to the School of Ministry one year later.

Another time, I led a workshop on prophetic arts at a Jesus Culture conference in Atlanta, Georgia. I taught the participants to ask the Holy Spirit for words of knowledge and then draw what they saw. Then I paired each of them up with someone they didn't know and had them create prophetic drawings for one another. The concepts were all new to them, so this was a big risk, but they took the challenge. One person drew three djembe drums, musical notes, and an iPod. Then he asked the woman I had paired him with, whom he had never met, what it meant to her. She was shocked. He had drawn her life's passion! She had just finished her music degree, she played the djembe to reach out to people in the marketplace, and her favorite possession was her iPod. It got even more crazy when she pulled out her iPod from her purse and put it down on the drawing she had

received. It was exactly the same model and size—talk about hearing from the Holy Spirit!

If you release youth into experiences in which they get to partner with the Holy Spirit for healing and prophecy in your church, then your church will become, as it should be, the most exciting and the best place for youth to hang out!

## *Worship*

God is raising us up in a divine partnership to bring down Heaven's sounds, colors, movement, and creativity, all in worship to the King of kings. It's time for all the arts to bring glory to God as we learn to sing the songs of Heaven, dance our love for Him, and paint anointed visions in His presence! There is nothing like this. At Bethel and many other places around the globe, the arts in worship are blending together like a mighty symphony to honor Him. Incredible encounters take place as worshippers engage in these powerful worship sessions where all the arts have a place. We are seeing a community of creatives emerge that will partner in harmony to see Heaven open. If you have never seen live worship before at Bethel on a Sunday night, you can visit our Website and view it through Web streaming.[2]

> **The arts in worship are blending together like a mighty symphony to honor Him.**

At a conference at Bethel, God gave me a vision of a picture to paint of a woman looking up at the stars at night and told me this painting was for someone's destiny. As people came up af-

ter the service to comment on my painting, many said that I had drawn them. One woman said that she was from an evangelical church and had never seen hands raised in service nor art done on stage. At first, she was afraid, but then when I began to paint, she realized I was painting her life. She had always wanted to go to other nations and become a missionary, but had not been able to. Through this painting, which she bought, she was able to go after her dreams because God had painted a visual of who she really is (which she had previously pushed under the carpet). This is the power of arts during worship!

In some of our worship services, we have set up long tables where people can create and places for children to use dry media and butcher block paper. We have also had writers write interpretations for the paintings on stage and then share them with the whole congregation after worship. During our School of Supernatural Creativity, we had dramas, dance numbers, and spoken words after each worship slot.

Once I was painting during a worship service in South Africa. I knew I was supposed to paint a roaring lion, which is especially meaningful in Africa, to awaken the Body of Christ to the power of God's presence. As I was painting this, I suddenly realized that the lion was laughing. I have never seen a lion laugh, but my lion was definitely laughing. At the end of the service, laughter and joy in God's presence broke out all over the room! The next night in worship, they started singing, "In the jungle, the mighty jungle, the lion laughs tonight," as they were holding up my painting. It was a visual of God's presence. Many believers have not experienced Him as joyful. The painting broke off misconceptions about who God is and exalted the fact that Jesus was anointed with joy above His companions (see Heb. 1:9)! Come on, somebody get happy!

## Welcome Ministry, Staff, and Small Groups

Supernatural creativity can impact people who are coming to your church for the first time. During the school year, I have the School of Ministry students sit at Bethel's welcome table and prophesy to newcomers through destiny cards, singing, and playing instruments over people. People, some for the first time, hear a love song from their Father in Heaven or receive a picture about God's thoughts for them, which can radically transform their lives. There are so many creative avenues to bless those who are looking to belong at our welcome centers.

The arts not only bless those who come to church, but they also communicate value to those involved in serving and ministering to others. At Bethel, the staff members are often the unsung heroes who keep everything afloat. I have had my students create things to encourage and speak destiny over Bethel staff and have seen the profuse thank-you notes they get in return. These creations include everything from baking, making art pieces, writing, and much more. We have also ministered with prophetic creativity to different groups in the church, like men's and women's groups. People from the church now contact me on a regular basis, asking if I can send a team down to minister through creativity in the arts.

Here is a testimony to illustrate the value of creativity within your small groups. This year I spoke at one of our Bethel women's groups. I had my team call out people from the audience and give them a prophetic word through pictures they had drawn. One of my team drew a picture of a path with light coming in on it. The person she called up was a man, who definitely stood out among the hundreds of women! When he came up, she explained that the painting prophesied about a new season coming to him. I asked him if this new season had to do with his relationship with God. He said yes and gave his life to the Lord right there in front of all of the women. God is so good! I can just hear him sharing his testimony about his

salvation years from now: "I gave my heart through a painting at a women's event!" God has a sense of humor and can find you no matter where you are!

## Groups to Pastor the Creatives

We have many groups that pastor creative people in our church. Some focus on a certain creative expression, such as fashion, worship, music, dance, art, drama, or writing, while others are for all kinds and levels of artists. They all focus on building a community of people who can grow in supernatural creativity through sharing ideas and creating together. We also have groups that are focused on helping people reach excellence within their creative field.

Tiffany Christiansen has done an incredible job of building a dramatic community here at Bethel. She put on a full-length play, *Wyntor's Kiss,* and she has helped oversee the dramatic pieces at the School of Supernatural Creativity for the last two years. Our arts apprenticeship group meets every week and is committed to developing artists who walk in the supernatural and have strong technical abilities. This group is all about family and working creatively together. They have done art projects for the School of Creativity and other conferences.

## Intercessors

You may come from a background where an intercessor's group meets together, sifts through prayer cards, intercedes for each one, and then goes home. At Bethel, the model is totally different. Our lead intercessor, Marla Baum, has introduced a strategy that involves supernatural creativity. The intercessors put together ideas and make blueprints for how to go about interceding for each situation, event, or person. When people come in to receive prayer ministry from the intercessors, they encounter music, prophetic art, Communion, foot washing, pillows to soak

on, creative cards, writings, gifts that the intercessors have made, and much more. The intercessors are involved in each Bethel conference as well. If you want to find out the joy and creative journey of intercession in revival, you need to get Beni Johnson's book, *The Happy Intercessor*.[3]

During our trip to the Philippines, I released "spiritual spa" intercession over the church leaders there. My team put together our blueprint and set it up. We had a foot washing station for the leaders to be cleansed and honored and a destiny art and writing section, from which they could take home a prophetic picture and word. We had a knighting station with a balloon sword, where we commissioned them in supernatural power. At another section, we served them Communion so they could receive His presence. We had 150 people to minister to, so it took us about two hours to get everyone through the "spa." Everyone wanted to get something from every station. Afterward, the head pastor said, "I am taking this to India and to the other countries where I go to refresh the leaders!" We modeled it, they experienced it, and now they have it, because it is so easy to duplicate. Everyone needs to experience a "spiritual spa" for refreshing.

## Healing Rooms

Perhaps you have healing rooms or are thinking about starting them in your church or area. The leader of the Bethel healing rooms, Joaquin Evans, was wondering what he could do to build his healing teams and enhance the experience for those receiving healing. I talked with him about introducing the arts and supernatural creativity to the healing rooms. They added worship in the waiting room, then painting, then dancing, and now include other creative expressions. People are now getting healed in the waiting room *before* they receive prayer from anyone, just by being in His presence through the atmosphere that has been created! They call the waiting room, "the Encounter Room." The healing rooms are lined with

volunteers who can't wait to create and release His presence creatively so others can be healed.

Here are some testimonies from the healing rooms to stir your faith. A person came into the healing rooms who had a brain tumor with stage four cancer and related vision problems. She had been given two weeks to live. After listening to the woman share her hopeless situation, the ministry leader that day, Kate, led her to someone who was painting a picture with the word *hope* written on it and told the woman to stand there and receive. It is amazing how something visual can give us God's perspective! People gathered around her to pray, and as she was looking at this painting, her vision was restored. Miraculously, the cancerous tumor then oozed out of her ear, and she was completely healed, which was verified from the doctor when she returned home! Another miracle took place after Saara Taina danced with a key chain given to her by parents whose five-year-old daughter had leukemia. Afterward, the parents took their child to the doctor, and the leukemia was gone!

Here is another testimony from Louisa Barry, who paints in the healing rooms:

> I began painting for a woman who had never seen prophetic art before. I explained that I was releasing angelic breakthrough. I didn't want to control or shape the image, as we can't control the angelic presence that brings healing. I continued painting and didn't look at the bigger picture to see how it was turning out. The woman said she saw a door in the painting and felt like God took her through a door to Heaven. She was able to receive full healing from fibromyalgia. Also she had three lumps of cancerous skin cells, which dissolved into baby skin. One was on her collarbone and the other two were in the corner of her eyes. I gave her the painting as a gift and she was so happy she cried!

There is so much supernatural power released when we partner with Heaven for healing. I hope you are getting excited!

## School of Ministry

We have a large School of Ministry, which continues to grow. Our second year class has now moved from Bethel's large campus because of volume. These students are taught how to hear from God and how to heal the sick. Each week, they release supernatural creativity to bring God's love in the marketplace. I have worked as an overseer and pastor in the School now for eight years, and I am amazed at the net being created as our students take the supernatural around the globe after they leave our school. God is raising up a mighty army of revivalists who know how to walk in love, character, and the supernatural—creatively partnering with His presence,

> **Training up the whole person needs to be our goal if we are going to see revival.**

Not only is the school expanding in size, but it also is expanding in vision. We want to raise up world changers to go into every realm of society: church, family, business, arts and entertainment, media, and government. As this happens, God's presence will not only transform the Body of Christ, but also all of culture. One of the ways we are raising up these students is through specific training tracks in their spheres of interest. As I have overseen the Kingdom Creativity Track, I have had the privilege of seeing each student pursue his or her call in the arts and media. People are now coming here to be trained up in supernatural arts because, while universities offer technical skills, they neither address the spiritual

or supernatural component nor train students in character and core values. Training up the whole person needs to be our goal if we are going to see revival.

At BSSM, I teach classes on gaining skills and prophetic understanding in the arts. Trisha Wheeler, a pastor in first year, teaches art classes focused on gaining freedom and breakthrough in creativity. We have classes on writing and other creative expressions. One activation area I have developed in the school is called "prophetic destiny art," where students create art pieces for incoming students, releasing their destiny before they come to their classes every day.

These radical creatives have partnered with Heaven throughout their school experience. Some have produced a supernatural art card line. Others have written, mixed, and produced many songs. One group of students wrote, directed, and produced a movie dealing with abortion issues. Another student started a fashion line called Adoria and puts on an annual fashion show. Students have put together photography and art books, created major art events, and have helped renovate people's living situations. Many are now pursuing their degrees in either visual or performing arts. They are leading prophetic art conferences at their churches back home. Some of them are illustrating and writing children's books, writing fiction, or producing films. They are free to dream, experiment, explore, and create—all with one end, to glorify God and to restore supernatural arts to a place of relevance in our culture.

One of my students, Francesco Sideli, who has a degree in art, came to the school hungry for the supernatural and to encounter God. As he began partnering with the Holy Spirit, his creativity became supernatural. People were healed when he drew a circle with chalk and they stepped into that circle. Once, he was painting during worship at a church in San Francisco. A woman came up and wanted to buy the painting. He asked her if she had any

pain, and she said she had suffered her whole life with ankle pain that made it hard to walk. Francesco said, "Put your hand in the middle of this picture." She did, and she was instantly healed. All the pain left her body! After graduating from the school of ministry, Francesco interned with me. He began to teach students how to think outside of the box with supernatural creativity, and he began to make inroads into the arts community in Redding. Now the city calls him if they need anything done artistically. We are transforming cities through creativity—one painting, song, dance, and drama at a time!

## Building Arts Communities in Other Places

As I speak on creativity at Bethel conferences and put on prophetic arts and creativity conferences at other churches, I am amazed at how life-changing creativity can be when people are taught to create with the Holy Spirit. I am also excited about how many artists and creative people are feeling valued and are finding their place in the Body of Christ! What is even more exciting is to hear back from these churches and see what they are producing and creating. Darwin Fuller, a pastor in Ventura county, shares about the impact of what can happen to a region when creativity in the supernatural is modeled:

> The teams that have come down from Bethel have been integral in weaving together our revival community. These Firestorms [BSSM regional outreaches] played a part in introducing revival focused leaders to each other on a deeper level, facilitating partnerships through the events, and teaching the different churches how to come together as the people of God and partner with His creative flow.
>
> When Theresa Dedmon came, the churches were activated in prophetic art, singing, prophesying, healing,

miracles, and various "out of the box" forms of street evangelism! It was always an atmosphere of risk, faith, and partnering with God to see what He was going to do next! These were special times that I'll never forget. It was the beginning of our local churches learning how to be a prophetic community that is united under the banner of His presence and a hunger for revival in the land. We have truly begun to grasp the revelation that it is not about building our individual churches, but partnering together to build God's Kingdom by the creativity and power of His presence!

## Pastoring Supernatural Creativity

I have found that there are four key components in developing supernatural creativity within a church: First, you need to develop a consistent team, which has pastoral oversight and established outlets, where people are able to create and see the impact of what they do. Second, there needs to be a value for gifted artisans to come and grow in the church community and the creative community. The third component is that the pastoral staff needs to publicly value arts and creativity through what they allow to happen in church and how they value it on a Sunday morning. Lastly, the team needs to be trained in risk-taking as they pursue the supernatural through what they create both inside and outside the church. They need to be trained to rely on the Holy Spirit instead of merely creating in their own strength because this prevents them from relying on mere human ability alone. They also need to be trained to pursue healing and the prophetic through what they create. All of the testimonies that you have read in the book have reached you because people took the time to write down their experiences for the next generation. Make sure that you record the testimonies. Let's share the good news and spur one another to go after the more of God!

Another way that you or your church can begin to be exposed to the power of supernatural creativity is for a team to come and model it so that the church can have an example for what is possible. Find out if the leadership pastoral staff would like this, and then contact me, and we will send a team to your area! Once the church acquires an understanding of the supernatural through creative expressions, they will want to continue it in the life of the church.

## Creative Dream Exercise for Your Church

*Write down creative outlets that you would like to see established in your church and begin to ask God to open up doors for this to begin to flourish.*

_____

_____

_____

_____

*How can you begin to partner with God's supernatural creativity in touching others in your church?*

_____

_____

_____

_____

*What steps do you need to take to release creativity within your church body? When and how could you start this process?*

_____

_____

*What dreams do you have for the different groups and people in your church to be released in creativity?*

*Find out what the pastor's vision is and see if the pastor has a heart for releasing more creative expressions in the church. Ask whether your pastor might want to host a team from Bethel to come and help train in this area.*

# Endnotes

1. Theresa Dedmon, *Cultivating Kingdom Creativity*, manual (Redding, CA: self-publised, 2009), http://store.ibethel.org/p4056/cultivating-kingdom-creativity; accessed December 21, 2011.

2. Bethel's Website: www.ibethel.org.

3. Beni Johnson, *The Happy Intercessor* (Shippensburg, PA: Destiny Image, 2009).

# Touching the City Through Kingdom Creativity

I love to watch new parents who have never changed a diaper and have no idea that this little life will let them know exactly what he or she needs—or what it will be like to tend to those needs for the next 18-plus years! I can say this with a chuckle because I have raised children of my own and understand that parental love not only takes sacrifice, but time, resources, car keys, and lots of Band-Aids throughout the years!

God's intent is that His Church would care for cities and communities like children—that we would love them, nurture them, change their poopy diapers, and celebrate their lives! We are called to pray for our land (see 2 Chron. 7:14) and use the resources we have been given to influence and transform it. Supernatural creativity and celebration are key resources for loving our cities, finding their needs and desires, and discovering ways to draw the gold within them to the surface. If we are going to take our cities into our arms like brand-new babies, then we have to know our aim and purpose for them.

## What Is Our Intent?

Unfortunately, we have often seen people force their agenda or Christian beliefs onto others, making people feel used or manipulated and usually leading them to walk away. Many times, they aren't rejecting the message, but the way it is presented and the intent of the messenger. People can tell if we are coming to bless them and if we support their agenda.

> **People want the message in a way that is valuable to them.**

Many Christians come across like Aunt Clara in one of my favorite classic movies, *A Christmas Story*.[1] In the movie, schoolboy Ralphie receives a Christmas present from his Aunt Clara—a full-body, fluffy, pink bunny suit. Ralphie hates the gift and says that Aunt Clara must think that he is a four-year-old girl. We all know what it's like to get gifts that we don't really want (most of mine are sitting in the garage). Our hearts might be right, but we won't have an impact if we are offering gifts people don't want. When Christians sing outdated songs like "Kumbaya" in public, they look like Ralphie coming to school in his pink bunny suit. Nobody even knows what that word means anymore!

Many of us sing songs about bringing revival to our cities, but how are we communicating this message and is it relevant? If we come with our own agenda and do not truly *know* the needs of the people we want to reach, we will never see the harvest. A good farmer has to know the seeds he is planting: how much water they need, how far apart to plant the seeds, and what fertilizers they need for growth. In much the same way, we need to know the people in our communities and their basic needs if we are to yield a harvest. If

our intent is to love compassionately, than knowing the hearts of the people we hope to reach will be more important than "filling our quota." God is not interested in people hearing the message as much as us "becoming the message," as Jesus did. He spoke in parables that used relevant cultural references so that those who were searching would find truth.

As I walk among people in the marketplace, I can feel their needs and hear their cries because I have sat with them, drawn pictures for them, and taken the time to hear their stories. I have carried their groceries, walked in their capital buildings, met with their mayors, and ministered to the broken in the city dumps. And I can tell you what they are looking for: you! You are called to be who you are and to proclaim the good news that they are valuable to God and that He is madly in love with them. It is time to put off religious mindsets and just love people. We need to come to them, identifying with their needs and concerns, bringing them the supernatural power and love of God. They are the lost coin that we need to find! Are you ready to take ownership and love your city as if it were your own child? If so, read on…

## Relevancy of the Arts

Art is relevant to everyone on this planet. It is the language every culture speaks, and it has the power to bypass religious boxes or walls of prejudice and fear and build a bridge into people's hearts. When historians and scientists study a culture, they unearth the artistic and creative makings that reflect what that culture valued and deemed important. The arts have always helped shape society, creating corporate identity within its members. They can penetrate corrupt governments and sinking economies. All society celebrates life through the arts. So what would it look like if our culture began to see life from Heaven's perspective? Quite frankly, the demonic movies and books on the market sell because people in society innately know there is more to this life than flesh and bone. Instead of

being outraged, let's create something that talks about spiritual wars and who really wins them. Why not use our energy to create classics like *The Lord of the Rings* that portray the power of community, faithfulness, and quests to overthrow evil?

Again, our intent in transforming culture must start with love and knowing people as God knows them. The message has to be about them and not about us. We have to see what single moms, business owners, or teens struggle with and the pressures they face every day. As we do this, we will *know* the message because we will have them in our hearts. The Gospels and the Book of Acts are my watering ground in this regard because I can feel so much love for others oozing out of these relationships. Jesus, the Son of God, spent His days on earth expressing compassion for others by healing the sick, eating with sinners, and sitting with outcasts like the woman at the well. Likewise, Paul the Apostle got up after being stoned and preached again, laying down his life so that the Gentiles (you and I) would come into the Kingdom. Love really will pay any price.

## The Message

I believe people are looking to be known and found. This message is found in my husband's book, *The Ultimate Treasure Hunt,* which I mentioned earlier. On these treasure hunts, people learn to find God's treasure as they reach out to people out in public places. They experience this when the message is about something they can relate to or it fills a desire or need. When you give people something they really want, your value to them increases. If Aunt Clara had sent Ralphie an official Red Ryder BB gun, he would have valued her quite differently! And when you address a desire or need that is hidden inside a person, he or she can recognize the supernatural power that gave you knowledge you wouldn't otherwise have. This is why we are to earnestly pursue supernatural gifts. Partnership with the Holy Spirit through words of knowledge and prophecy reveals what is buried in peoples' hearts and opens doors to their lives.

Remember, everything we prophesy must be for strengthening, encouraging, and comforting others (see 1 Cor. 14:3). It is not to scare people or to predict dates or doom. Most people already know where they fall short. They don't know God unconditionally loves them. The kindness of God leads people to repentance.

Let me share with you a quick testimony about how to use prophetic ministry with supernatural creativity in the marketplace. One day, after praying in the morning, I decided to create a card. I drew a simple picture of a person trekking up a mountain on the front, and inside I wrote, "You can climb to the top of any mountain because God is always with you. He will never leave you or forsake you." I tucked the card away inside my purse, planning to give it away to someone I would meet that day. That evening, my husband and I went out to dinner, and I noticed that the card was still in my bag. I looked up and saw a woman with her head down, sitting on the curb of the restaurant parking lot. I didn't know for sure whether I should push forward and approach her, so I quickly prayed, "Lord, if she comes in the door of the restaurant, I will give it to her."

We sat down in the restaurant, and I thought I was off the hook. But then I looked over and saw the woman coming into the restaurant. At that point, I knew I had a choice—I could either continue my nice meal with Kevin, or I could take a *risk*. I decided to go for it. I went over to the entrance of the restaurant and waited for her to finish her conversation with the manager. When she was done, I intercepted her as she headed for the front door and said, "Excuse me, this won't take long. I know this sounds strange, but I believe that I made a card for you this morning. Would you mind if I read it and showed it to you?" She looked startled, but said, "Uh, no, go ahead." I could tell she was intrigued—after all, how many homemade cards have you received from a stranger?

So I showed her the card and the picture. Instantly, she shrieked and collapsed in my arms! It was quite a shriek—it seemed the

whole restaurant turned to look at us. I asked, "Does that mean anything to you?" I knew it must have, but I also know people need time to process. She told me that her ex-boyfriend, whom she had been living with for years, had just come into the restaurant with his fiancée! I then used the message of the card—that God would never leave her like her boyfriend or forsake her—to minister to her. We had quite the God-time, and she ended up completely transformed. That's how easy it is to use the tools of supernatural creativity!

## Create touching points in your city.

We can also partner with what our city values and create "touching points" for people to experience God. I knew that our city would benefit from a story hour for children at our public library, so I asked if we could do this. The city not only wanted us to do this on Saturdays, but asked us to help with events for 500-800 people. We did face-painting, balloon animals, and drawings, and we transformed so many children's lives. Every time I see the people who head up the library programs, a big smile crosses their face as they thank me profusely.

## *Healing*

Another door into the marketplace in supernatural creativity is healing. The process is so easy that children can do it. You just ask God for a word of knowledge for healing and then link it with a picture, writing, song, or prophetic act. When people get healed, they are then open to *everything* you have to say because they have seen the supernatural power of God transform their lives.

Holly Smith, an incoming School of Ministry student, had a word of knowledge about eyes being healed and drew a very distinct

set of box-looking glasses. She went to a local coffee shop in Redding that night and kept looking for the glasses she had drawn, but with no success. Finally, as she was walking out the door, she stopped in her tracks. She saw a man wearing the *exact* glasses she had drawn! She went up to him and showed him the glasses, which opened the door for her to pray for his healing. As she prayed, he was completely healed. He said, "I couldn't read that before!"

Just recently, another student, Michelle, was ministering at our Rescue Mission for the homeless and found out it was the birthday of a woman staying at the Mission—and that this woman had back pain. Michelle went up to her like any supernatural creative and declared that after she sang "Happy Birthday" to her, all of the pain in her back would leave. Sure enough, after Michelle sang the song, the woman checked her back, and all the pain had gone! Now, that's a *"Happy* Birthday" that needs to be sung in the Hallmark card section. God is *that good!*

## *The Approach*

Many people have not been trained to build rapport with others, which makes ministry in the marketplace scary, unfamiliar, and frustrating. Here are some suggestions I use in ministry training to help you take the risk and see people in your city and neighborhoods transformed:

1. *Get filled up!* Before you go out, make sure you take time to soak in His presence. Ask God for favor, anointing, and revelation of what the Father is doing in Heaven. You can also invite someone to go out with you; this creates partnership on earth as well. Decide to love people before you meet them out in the marketplace.

2. *When you approach someone, smile and extend your hand.* How many people smile and get greeted as though they

are the only one on the planet? This exudes favor and invitation.

3. *Engage the person through comments or questions.* Compliment their clothes, their children, what they are buying, or anything God shows you about them. Then ask them questions about what they did for the last holiday or what they have planned for that day and then say something honoring about them: "You seem like a great mom." "Wow, you're a veteran. Thanks for serving our country!" "So tell me more about that business you started." As you are doing this, in the Spirit, ask God to show you what He is highlighting about them.

4. *Observe the person's mannerisms and tone of voice.* You want to see how the person is responding to you and to God's presence. If he is looking at the time, it means he is in a hurry. If she is easily distracted and looking away, keep the conversation short. Does he look relaxed, with an open stance? This means he is very interested in the conversation. You can always ask, "Am I keeping you from something important?"

5. *Avoid words and phrases they don't understand.* Yeah, we can say it—sometimes we have lived so long in a Christian bubble that we don't know how to speak without using Christianese. It's like when the doctor says, "You have doldoetrouaz and you need to take the drug Plakeurs." What? You want to scream, "Can you speak in terms I can understand?" Take time and begin to listen to how people speak to each other in movies, find out what songs are popular, what is happening in the news, and ask them questions about the holidays or other things that can relate to them. Then tie that in to what you are talking about. When Nathan talked to David about Bathsheba, he used a story about a lamb because David was a shepherd (see

2 Sam. 12). Think about where you are meeting people and why they might be there.

6. *Find common ground with those you meet.* Discover something you can both chat about—this builds rapport and makes people feel comfortable.

7. *Avoid manipulation and control. Rather, honor and ask questions.* When we say, "The Lord told me," or try to persuade people into our way of thinking, we are taking away their free will. Jesus asked, *"What do you want Me to do for you?"* (Mark 10:36). He asked even when it was obvious the person needed healing. We can phrase our questions in the same way: "I believe the Lord said _____, but I could be wrong, what do you think?" "I have seen people healed of AIDS. Would it be OK if we prayed about that right now?"

8. *We need to look for the zone.* When a person's heart is turned toward God through supernatural creativity and meaningful conversation, something happens and that person's heart opens up. At this time, you know that the Holy Spirit is really working and you can begin to ask God supernaturally what He wants to do next. Does this person want to know God, be filled with the Spirit, get plugged in to a great church, or get more prophetic ministry? Are there other creative expressions that you can release? This is where you need to *depend* on the Holy Spirit! Follow your heart and the Holy Spirit's leading.

9. *There is no formula, only relationship!* Jesus never healed anyone the same way for a reason. He was looking for what the Father was doing for that particular person and situation. Our minds tend to want things to be the same because then we can follow a procedure. But we need to follow Jesus' footsteps of dependence on the Father.

The approach is something that you can use at any time and in any place to reach people. Now let's look at ways that you can be intentional in reaching your city through your unique gifts, talents, resources, and favor.

## Defining Your Passion, Gifts, Influence, and Resources

Throughout our lives, God gives us indicators of our calling through the way we *feel* about life—through that "inner knowing valve." For example, you sense something when you watch a movie about a certain person, and you know that that's what you want to do. If you pursue this passion, linking it to your dreams and to the people you really want to touch in your life, you will eventually reach a convergence where you are doing what you know you were born to do.

My passion for seeing churches reach their cities started when I was 13. My family and I would go to convalescent homes, veteran hospitals, prisons, orphanages, and city streets to touch people through music and drama. Everything inside me came alive as I saw people who felt sad, forgotten, and broken know the love of a Father who would never leave them. Every time I went out, I came back more energized.

What makes you come alive? Where would you want to go if you could go anywhere in your city? What creative ways would reach people there? What scenarios excite you? This passion needs to be linked to the people you are called to reach and transform. Our passions thrive when they benefit others because that is what they were created to do. So take some time and dream about the types of people you want to reach through your passion. For instance, if you have a passion for sports and love youth, why not go down to the YMCA to volunteer or play ball at one of the recreational facilities in your city?

Every one of us also has gifts, talents, and abilities given to us by our Father to transform our cities. As with our passions, the purpose of the abilities we have been given is to benefit others. Your gifts of music, arts, sports, ingenuity, intellectual abilities, leadership skills, counseling, administration, helps, and service are so key for transforming your life and city! Many of our School of Ministry students are beginning to use their talents and gifts to reach specific sectors in our city because they realized this was their city and their baby. One of our students with a degree in writing taught classes on poetry at the city of Redding's art department last year. People in our school are volunteering to mentor Redding's troubled youth. How can your gifts and talents benefit your city?

## Influence and Resources

No matter your age, occupation, or life experience, you have influence in your family, church, and community. Sometimes we are unaware of how this influence can be a stepping-stone for favor and for God's presence. We all have the power to walk into any store and carry His presence without saying a word. We can bless the shop owner by honoring the establishment, smiling, saying an encouraging word to the checker, and thanking him or her for the quality of merchandise. We can *shift the atmosphere* and see God's presence come wherever we go! This is what Jesus modeled as He went around the villages and areas where He lived, demonstrating the supernatural. Where do you have influence, either through your occupation, oversight, hobbies, or recreation?

Likewise, all of us have resources that can benefit others in our community. We may have businesses, material possessions, experiences, or other assets that can open up doors to transform others around us. For instance, if you have the gift of hospitality, own a wonderful home, and love to cook, why not use these resources to bless those you have a heart for in your city? What resources do you

have that are linked to your gifts, passions, and call? This is where you need to link your God-given creativity with what God has already given you in regard to influence.

## Bringing Supernatural Creativity to Redding!

God is preparing you to steward your city, and He will use all of your past experiences and resources to help you gain favor and to give you strategies and ideas. As I mentioned earlier, my first taste in transforming a city happened when I was young with my family. I gained more experience when my husband and I planted our church in Huntington Beach, where I was involved in many different kinds of creative expressions. I won awards from the city for booths I set up for annual events to benefit children. For the last nine years, I have been involved in citywide transformation in the Redding area, primarily through the School of Ministry. I *love* my city! One of the greatest advantages of bringing in creative strategies through the arts is that it benefits everyone and brings fun and joy into the community. My desire is to open Redding's eyes to see how wild and crazy God's love is through supernatural arts that express His beauty and truth.

> **One of the greatest advantages of bringing creativity through the arts is that it benefits everyone and brings joy into the community.**

We have approximately 15 teams that go out into Redding every week. We teach our teams to risk and pray that God would release signs and wonders through their creative expressions. Our desire is for every person on the team to be able to love others, risk and

face their fears, see the sick healed, and prophesy through their art forms. We have groups that focus on dance, drama in elementary schools, drama and prophetic acts, music, and interactive groups that combine all the arts. We also have teams that go to assigned neighborhoods and help with block parties, ministering to the people and building relationships on a weekly basis. Some go to coffee shops and set up art and music. We are now developing groups that will touch businesses by ministering to the owners and employees by prophesying through different arts and making an art piece that reflects the vision of their business. We want to create a culture of celebration, where we focus on key people or organizations in our city who are making a difference.

I just received an art in healing certificate so I can now lead teams into hospitals or shelters and minister to those who have been abused. We also will be partnering with our youth center and teaching art classes there on a weekly basis. Wherever there are people, we want to go! We always want to bring joy, fun, laughter, and smiles because we celebrate our community and its people. I ask the Holy Spirit to show me where the needs are in Redding and where the hunger is. Start to dream for your city and your region as you hear about the places we have invested in and how we are creating a momentum in loving our city.

## What Does It Look Like When You Go Out?

As our teams go out, they set up according to the vision for that particular day and event. If we are setting up in a park or doing a block party, we will have stations where children can receive a prophetic balloon animal, get their face painted, and receive words about their destiny. We will also have people doing art on easels, while others are giving out destiny drawings. We may have people playing the guitar and singing to people. After a lot of people have gathered, the dance or drama team performs. If we are in a coffee shop, we may set up musicians to perform and others will draw des-

tiny art while people come in. Some people make jewelry, others sculpt, and some do crafts for children. It all depends on the team and where we are going to set up so that we are sensitive to the needs of those around us.

We have released creative expressions all over Redding. Some have been effective and some haven't. One of my core values is that if you don't try, you will never learn what works. I highly value risk; as long as we are reaching out in love, while honoring businesses and people's needs, there will be fruit.

## *Testimony Time*

Once we did expressive portraits at Redding's mall. We set up 12 long tables and had stations for people to get a portrait, a destiny piece of art or destiny writing, and a station where children could create something. Over two days, we saw hundreds of people get prophetic words. Autism was healed, and others rededicated their lives to God. Storeowners asked us to draw for them. One man, after I prophesied over him by doing his portrait, was so touched that he went to his car and gave me a sculpture he had done. We have also done story hour on a regular basis in our library, performed at Barnes and Noble, played and created art at local coffee shops, and ministered in convalescent homes. We have ministered through the arts in our hospitals and schools, visited the sick, done break and interpretive dancing at our skate park, and offered professional photography for families in the park. We have ministered through all of the arts in neighborhoods, putting on block parties and visiting homes. We have done drawings and children's ministries at large Marketfest events, blues festivals, and New Age festivals. We set up, and He always comes.

Our creative arts team was once invited to set up at a conservative Christian college. We had destiny art, destiny body tattoos with markers, balloons, and a group that sang to people. During

the night, we had people and teachers coming up to us, their eyes filled with tears, describing how the team was reading their mail and hearing from God! Another time, we did destiny art at a New Age festival in Shasta City, California, inside a large gymnasium. As we came in to set up destiny writing and art, we could hear chanting going on over the loudspeaker. As we were busily drawing, all of a sudden, I heard one of our team members playing the congas and singing in the Spirit over the loud speaker. The New Agers liked it so much that they invited her back for another hour! It's amazing how much God wants to get in to the world's parties and show off!

Once, during a prophetic art treasure hunt, a person drew a circle with a line through it and a foot inside the circle. The group found a man who matched their clues and asked if he had pain in his left foot. He said he did, because he had just cut it on glass the night before. The moment they handed him the picture, all the pain left his foot. He took off his boot and bandage to find that the cut was completely gone as well! Another team decided to draw pictures before going out, and one member drew a picture symbolizing new life. They gave it away to a man who had just been in a fight with his girlfriend, was on his way to prison, and had turned away from God. When they gave him the picture, he started crying and shaking under the power of God. He felt God's presence so strongly that he almost couldn't stand. Just before they had met him, he had been contemplating death, but the picture and the prophetic words spoke life, hope, and strength to him. At the end of their time, he gave the team his drugs and decided to turn his life back to God. Another student, who felt drawn to government, drew a picture and made a card for the mayor with his contact information on it. She called him, and he was able to prophesy over her. She said it had really touched her and asked if they could talk again!

As I have mentioned before, we want to bring value to the children in our community. We prophesy and bless children through face

painting, balloon animals, and destiny art. We declare their destinies as we knight and crown them with balloons, signifying that they are royalty. We have everyone stop and clap after we announce, "Everybody, we have a princess or we have a knight." Then we ask them questions about what they are like and agree with Heaven that they are special and have a purpose. This creates a party and blesses the parents as well as the children. We offer this for free because we really want them to know that their children are worth the investment. Many times we gear what we do around a season or a community celebration. We have set up in front of Walmart at Christmas time, wrapping presents, passing out destiny Christmas cards, laughing, and loving on people. As we love the people in our community, opportunities arise to pray, prophesy, and see healings.

We are now seeing the fruit of our labors. People from different groups in Redding call us wanting us to come to different events. We are becoming known as the church that blesses people and brings compassion through creativity and healing. Here is the testimony of one of our team members:

> We were giving away roses and heart-shaped balloons for Valentine Day. We approached one woman, gave her gifts, and asked if she needed prayer for anything. She proceeded to share a testimony with us regarding her healing last year, after one of our groups had prayed for her. She had been scheduled for brain surgery, but after the prayer, she was healed! But she said the most remarkable part was that she encountered the love of God for the first time in her life.

## Placing Your City in Loving Arms

*You need to see your city as part of your inheritance. By doing this, you will find creative ways that your influence, gifts, and passions can benefit those in your city that you have passion to touch.*

1. What places in your city would you like to see transformed?

2. What types of people are you drawn to in your city?

3. What influence do you have in your city, community, and area either through business, recreation, or other community events?

4. What people have a similar passion or gift mix that you might team up with?

*5. Begin to pray and intercede for your city. Ask God to open opportunities for you. Be ready now to say yes and to sacrifice so others can be transformed in your city.*

# Endnote

1. *A Christmas Story;* see quote at http://www.tbs.com/stories/story/0,,125846,00.html; accessed December 23, 2011.

# The Power of Creativity to Transform Nations

I remember the first time we took our son, Chad, who was eight years old at the time, to Mexico with other members of our church to help build houses for the poor in Tijuana. Chad was happily playing catch with the children when their ball went into someone's house. He automatically went into the house to get it, and as he did, a giant rat ran out of the house. He looked up at me, and I knew he understood for the first time how different his life was from the children all around him.

 **Compassion breeds action.**

I believe we, as the Body of Christ, must venture into the homes, cities, and nations of those who live differently than we do. In fact, we are commanded to go into all nations for the purpose of making disciples (see Matt. 28:18-20). Making disciples means that we are

responsible, not only for own lives and country, but also for those who live beyond our borders. As we see how they live, our hearts will know what they need. Compassion breeds action and care. Once you see them through Jesus' eyes, you have to let them in.

I remember when I first discovered the power of walking in Kingdom identity in other nations. I was in the first year program at Bethel School of Supernatural Ministry, and we took a ten-day trip to Tijuana, Mexico, to bring revival. When I got there, one of the leaders, Mark Brookes, asked if I would head up the children's ministry both in the church services and in the marketplace. I gulped nervously, trying to downplay my anxiety, and said reluctantly, yes, and then yelled out to God for help. I felt led by the Spirit to organize our students to train the children in healing, the prophetic, and arts during the services. The impact was astounding! As they soaked in God's presence through worship music, children drew pictures of their families with God in Heaven, of the angelic, and of what God thought about them. My teams came back and told me that children were praying and seeing healing break out both with adults and with other children who were sick. As they learned to prophesy, they also began to share this with other children.

The miracles we saw in the services followed us into the villages. We set up in the town squares and put on dramas, painted faces, made balloon animals, and shared testimonies. Children and adults gave their lives to God and were healed and transformed by His love. We then invited them to that evening's church service so they could come and share the testimonies of how they were saved or healed.

After we left Tijuana, I looked around at the team I had trained. They didn't speak the language, but through interpreters, creativity, and love, they had transformed so many children's and adults' lives! This is the power of the arts—it is the modern-day "tongues" in which people hear God speaking to them in ways that they can understand, which goes beyond language barriers.

For close to a decade, I have seen firsthand how arts, creativity, and partnering with the Holy Spirit can transform nations. There are basic principles that bring transformation, all of which are based on the core values I have shared throughout this book and which need to be assimilated into your particular vision for the people and places you want to reach. As I share these principles, I would like you to begin to ask God to give you a heart for the nations. Even if you do not have vision to physically go overseas, God can give you the nations. There are many ways you can touch the world, but the first step is to ask God to show you right now which countries He desires to give you as your inheritance. Psalm 2:8 says, *"Ask of Me, and I will make the nations your inheritance, the ends of the earth your possession"* (NIV). We must understand that they are ours! We only need ask and then move forward in ways that can transform those nations. This is pivotal for us—transforming the world with the glory of God. So take a moment, put down this book, and ask God for the nations you desire.

## Wisdom, Understanding, and Alignment

If we want to see lasting fruit, we need divine wisdom as we build a structure for transforming nations. We also need to support Kingdom work within countries so disciples can be trained after we leave. If our approach is to sow seeds without showing others how to daily go to the watering hole or connecting them with a farmer, we will not have lasting fruit—we will only give them our fruit. What happens when we go away? Where will they go for sustenance? Do they know how to sow seeds?

Right now, begin to ask God for wisdom to guide you in your passion for the nations that are on your heart. Then begin to explore churches or organizations that are making an impact in those nations. Ask God for creative strategies that can bring about restoration in every area. Lastly, ask for understanding of the people that live in those areas. The more you know about them, the more

you will be able to know what they need and develop strategies for advancing the Kingdom. We need to be concerned with every area of life within these cultures. That's why many of our students are coming up with creative and innovative ideas for micro-loans so that poverty can begin to be abolished in these third-world countries. The Kingdom is to transform society spiritually, relationally, and culturally. This is the approach we must have if we are to bring creative supernatural transformation in the world.

> **The Kingdom of God is to transform society spiritually, relationally, and culturally.**

When I took a team of BSSM students to Norway, I had them study the governmental and educational structure of the country in order to determine how Kingdom core values could be established when we were there. We learned that many Norwegians subconsciously believe they are inferior and have low value because of governmental and religious influences from the past. So one of the areas that we addressed through the arts was their true identity as sons and daughters. We addressed this through dramas we wrote, teachings we brought, and other creative expressions to help them *"see"* and experience the truth about God's Kingdom within. We also taught the churches how to reach out in the marketplace through the arts and broke off their fear of sharing and being a voice in their communities.

That trip produced lasting effects in the churches with whom we had developed deep relationships. They are now using the arts when they do their own mission trips. We still receive testimonies about what these churches are doing. One of the women who loved art put

together a prophetic art calendar expressing the identity she found while we were there. After seeing people saved, healed, and set free through what they created when we were there, these churches are now releasing the same ministry all across the Nordic countries! God's creativity and love is transferrable! The more we become acquainted with the people of a particular nation, the more power we have for leaving a legacy of cultural transformation.

Here is a testimony from one of these trips. While in Norway, one of our team members gave away an art piece to a man in a coffee shop who had broken his wrist, and she invited him to the healing room service we were having that night. He told her that he was an atheist and wouldn't be coming. She told him to come anyway, explaining that healing is for everyone, whether or not people believe God exists. He came that night, holding his art piece, and he brought his girlfriend. We had set up the room with painting, worship, and dancing going on as people waited to get prayer. I had the opportunity to draw this man's portrait with his girlfriend. As I was talking to them, I began to prophesy into their lives. Through the painting and prophetic ministry, they both received Christ, and his wrist was healed as well. This happened because someone gave him an art piece that moved him to know more and come!

If we are going to bring the Kingdom of God to the nations God wants to give us, we must be aligned with how God sets up His Kingdom. If we study Acts, we realize that God's design is to set up churches in the nations. This is why Paul wrote his epistles. He wanted to encourage the churches he had started in those nations. We, in turn, need to have a vision for churches in other nations and how we can impact them. When people from Bethel go to other nations, our desire is to equip the local churches with what they need and release the supernatural. We train them to heal the sick, encounter God, and prophesy. We equip churches to use creativity in their approach by having our teams demonstrate risk-taking, while pursuing supernatural creative strategies to touch others. As we talk

to these churches, we also want to give them a heart for transforming their villages and their countries, so we also try to reach out to the government, family, and business sectors in that nation. God is breaking down the walls that have separated believers from being influencers within their nation. We are beginning to see what God can do as we are creatively led by the Holy Spirit to sow into other countries and their destinies.

## *Testimony from Rwanda*

In 1994, there was a massive genocide in the African nation of Rwanda. The Hutu tribe slaughtered around 800,000 Tutsi people over a 100-day period. Transformational Development Agency (TDA) has been leading the way to reform Rwanda. In 2010, they asked me to come and offer healing and educational services, featuring arts, to orphans who had seen their families massacred in the genocide. I brought a large team loaded with creative strategies, sewing machines, arts and crafts, passion, and a whole lot of love! I designed a program in which we spent the first part of the day laying a foundation for these orphans to understand their identity. In the afternoon, we taught workshops that helped them both to learn a trade and to deal with the pain they had gone through during the genocide. The workshops we offered were in photography, jewelry making, sewing, writing, dancing, music, drama, and card making.

These orphans, who were all around 18-25 years of age now, hadn't ever really been able to share their stories about the devastation they had witnessed firsthand. I asked the Holy Spirit for ways that their hearts could be healed and set free. The first day, I took them into an encounter in which their Father in Heaven adopted them, and then we gave them all adoption papers. Each day, we built upon their identity, taking time to help them forgive those who had killed their families, crowning them as royalty, and breaking off fear for their future in Rwanda. At the close of our time together, each

workshop participant shared what he or she had created and what God had done through that time. They were so proud of the purses, jewelry, cards, writing, and art they had made and the drama, dance, and songs they had learned. Even more importantly, we could see in their faces that they were no longer lost, lonely orphans.

We found that art was the vehicle through which they felt free to tell their stories and begin the healing process. As I was making cards with them, many shared with me where they were when the genocide first happened and where they hid to escape death. I asked them to draw this on their cards and to find out where God was and how He had protected them. One of them shared about how he had been thrown in a pit, covered up, and left for dead, unable to move. After days had gone by, a dog came by, dug up the ground, and dragged him out by his hand. He told us that God was in the dog that saved his life. At the end of our time with them, we visited their homes and saw their families. The artwork they had done was already hanging on the walls, and the Bible and art supplies we had given them were proudly displayed on their tables.

> We are Christ's ambassadors, revealing the Kingdom and leaving a lasting legacy behind.

Many of these young men and women now have successful jobs either in the arts or other areas because they know their Father in Heaven loves them! TDA is continuing to help them build a strong Christian foundation and disciple them. One of these orphans, the man left for dead in the pit, made a picture for us that said, "Thank you for coming when no one else did and for showing us the true

compassion of Christ." One of our team was even granted audience with the president and told him what we were doing. He said, "Please tell them thank you for coming and blessing my country." This is what it means to be an ambassador for Christ, revealing His Kingdom and leaving a lasting legacy behind.

## *The Impact of Supernatural Creativity Around the Globe!*

Proverbs 18:16 says, *"A gift opens the way for the giver and ushers him into the presence of the great"* (NIV). We have seen gifts of supernatural creativity usher our teams into the presence of governmental leaders whose hearts are opened to hear God's plans for them and for their countries.

Here are highlights from various trips that the students have been on to showcase the power of supernatural creativity. In Mexico, prophetic songs and drawings created by our students brought healing to multiple people. Specifically, one joy painting led to a family restoration, forgiveness, and deliverance. A dance released in a church led to dozens of people being healed without anyone praying for them, and a child's painting released healing, and someone's eyes improved. In Tepic, Mexico, a witch doctor was healed and then got saved. After this experience, he received prophetic art, and asked us for a way he could teach this to his whole village. When I led a team to the city of La Paz, Mexico, we performed a drama in a prison about the lies that keep people from their identity. Not only did many prisoners get saved, but the warden himself came to Jesus. This is the sweet fragrance of Christ. Things shift as we release the supernatural power of God, and lives are transformed!

Often we don't speak the language, but the arts and creativity can open up doors into demonstrations of His love. In Honduras, simple crowns released identity to poor children who then called

out the destiny in each other's lives. In Nicaragua, marker tattoos brought healing and salvation to many people in the marketplace.

In Ecuador, children drew pictures of their encounters with God, and 13 people gave their lives to Christ. In worship, a person drew a picture of an eye, and over 20 eye problems were healed!

In England, students drew and painted declarations on shoes to bring out the identity in each one! When I was in England, a friend and musician, Dennis Stritmatter, played his guitar to release the presence of God in healing in a church, and instantly approximately 20 people were healed physically in the room—without anyone praying!

In South Africa, a baby walked after a piece of art was made. I had the privilege of writing a simple drama called, "The Father Gets His Kids Back," which led a thousand children in South Africa to give their lives to Christ.[1] In the Congo, our students did prophetic healing art pieces for women and children who had been raped and abandoned. In Rwanda, we gave away a hundred bracelets to prostitutes, many who had just given their lives to Christ. A student who couldn't go to Rwanda made these bracelets, which exemplifies that our gifts of creativity can have a powerful impact, even if we can't go ourselves.

A student named Kimberly Humphrey asked the Holy Spirit what she should bring on her trip to Mozambique, Africa, and she brought four 8-ounce tubes of paints. She miraculously painted four murals in prisons during the time she was there! Some of the walls were 10 feet by 8 feet. When she returned, there was *still* paint in those tubes. If God can multiply food to feed the hungry, He can multiply paint to save the nations! As prisoners look at the murals, they are coming to Christ. The door of hope and freedom has been found behind prison bars. Now, she has been asked to come back to Mozambique to paint more murals, bringing God's love. This is the power of art. We cannot preach daily in prison,

but these murals are worth more than a government pardon! They show the way to an eternal home!

When I went to the Philippines, our team led workshops in creative expressions so the people in Manila could not only be equipped, but also could go out with us to bring God's love and supernatural power. We had workshops in body art, destiny writing and cards, face painting, balloons, prophetic singing, rapping, destiny photography, and drama. Each one was bringing their gifts and showing others how to prophesy and bring healing through their creative expression. Then we left for different sites around Manila. When we returned, what we heard was phenomenal! Countless Filipinos led people to Christ, witnessed healing, and learned to prophesy.

One drama team, along with our ventriloquist, Marc Griffiths, got lost. So these passionate Filipinos just set up at a park and performed. Their hunger attracted Heaven. People received Christ and were healed. We had the privilege of ministering through song, writing, and art to many governmental officials within each city that we visited in the Philippines. Senators, mayors, and governmental officials all were touched by the love of God! In particular, one man whom we had prophesied over the previous year about promotion was promoted in his city and wanted to thank us for the word we had given him. We gave him more paintings, which he wanted to put up on his wall.

## Partnering with Your City and Community for Global Impact

I assume that by now you are beginning to understand how collaborating with the Holy Spirit through different creative expressions can bring transformation around the globe. We have made a YouTube video that describes how our school's missionary trips are transforming the nations through creativity, which you are welcome

to view.[2] What about awakening your city to the needs of those who are on foreign soil?

In 2010, I put on a Kingdom School of Creativity at Bethel, which ended with an all-day arts festival called Heart4Nations in one of our parks. Local bands, dance academies, and drama groups came down and performed, and artists showcased their artwork. My team strategically created booths that would make people aware of the needs of the children in Africa, but would also covertly bring the Kingdom into people's lives and carry the power of the supernatural to transform them. We set up booths for dream interpretation, destiny writing, destiny cards, hourly crafts for children, destiny makeovers (makeup and hair), healing, and massage, as well as food from around the world. We included an art walk entitled, "Have you walked a mile in my shoes?" where people could see pictures and shoes from people around the world with descriptions of their lives. (These were gathered from the different mission teams that had gone out to touch nations.)

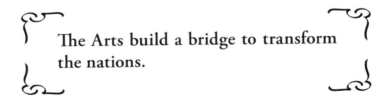

**The Arts build a bridge to transform the nations.**

All of the proceeds from this event went to three organizations we felt were really making an impact in touching Africa's children. The fruit from this event was amazing! We saw about 50 people get healed at the healing and massage station, not to mention all the ones who were touched through prophetic ministry throughout the day. This was not advertised as a church or Christian event, but as a community event. We have an awesome privilege to meet the needs of the nations by building a bridge through the arts and even giving non-Christians the chance to sow into their breakthrough!

## Creativity That Transforms Mindsets

What would happen if people who are excellent in their fields decided to radically transform the culture around them? This is what happened when Rick Weineke decided to tell the story of the Holocaust through Christ's sacrifice in a sculpture series entitled "Fountain of Tears." Most people would not parallel the Holocaust with Christ's sacrifice, but this is exactly why the message is so powerful. Weineke's sculpture in Israel is 60 feet wide and 12 feet high.

> The sculpture shows how, through the course of suffering His own execution, Christ is able to identify and empathize with his Jewish brothers and sisters who suffered during the Holocaust. The sculpture follows the seven last words of Christ that he spoke during his execution. It is made up of seven panels. Each panel has a carving of Christ hanging on the cross, carved into a 60 foot wall made of Jerusalem stone. Standing in front of each panel is a corresponding bronze sculpture of a Holocaust victim, whose head is shaved and who wears the characteristic striped prison garb. Each panel shows one of the stages of grieving that each went through on their path towards death. The sculpture is in fact a study of the grieving process.[3]

Many Jews and Christians alike visit this sculpture to understand the power of identification, which is embodied in Jesus' broken body. Here is one story about a Jewish woman who visited the site:

> When she saw the sculpture, especially the panel where Christ's head is shaved and his arm bears the tattooed number, she broke into tears. She at that moment remembered when she was five years old and she would daily try to scrub the tattooed numbers off of her father's arm, because she knew that it was the reason that he could not

speak or communicate with her. She was so profoundly touched by the image of Christ, suffering side by side with the Holocaust victims, that she asked the artist to make a scaled down version for her to put in her home. She admitted that as a secular Jewish woman, the idea of Jesus as the messiah/healer had never made any sense to her whatsoever, but now felt that through the message of the sculpture there may be a pathway to healing for Holocaust survivors, and children of survivors, such as herself who had grown up profoundly affected by the brokenness and the pain of her parents.[4]

Filmmaker Christy Peters, who has worked with Radar pictures and Warner Brother Studios, has decided to put a film together telling Weineke's story. Christy has always had a passion for filmmaking, but her greatest desire is to see film and art used for higher purposes for the Kingdom of God.

## *Fashion That Clothes the Poor*

The arts impact every part of our lives, including the clothes we wear. One woman, Carol Anderson, is using her influence in the fashion arena to impact nations. Carol was a designer for department stores such as Nordstrom and Neiman Marcus, but chose to follow a dream of expanding her creativity for design into CAbi, a company she built that brings fashion to women in the privacy of their homes all across the world:

> CAbi works to fulfill the mission of empowering disenfranchised women with a greater opportunity through the gifts of our clothing, financial support, our volunteer efforts, all given in the spirit of God's love. CAbi is all about affecting lives through relationships, and through The Heart of CAbi Foundation, we get to impact the lives of women in need in the United States and around

the world. Over 25 million dollars in CAbi clothing and hundreds of thousands of dollars have been donated to domestic and international nonprofit organizations that are dedicated to impacting women in need.[5]

In less than five years time, one fashion designer is obliterating abject poverty and transforming women's mindsets! Johanne Johnson, a friend of mine and a distributor for CAbi, says,

> It's amazing how God can take one woman's dream, ten women's passion for building relationships, and now 3,200 women who represent CAbi as consultants, to bring change to a world desperate for God's love. Who would have thought my love for beautiful things and fashion could be a vehicle for me to make a change in the world one relationship at a time?

We must start with the influence that we have and sow into the lives of those who will be the next future Carol Andersons! At Bethel, our students have put on multiple fashion shows with designers who want to restore creativity and excellence through what women wear. These designers are now going back to their countries and across America to create their own clothing lines that let people know their true identity and not get caught up in the wrong image of who they are.

God is calling artisans to sing, dance, paint, write, design, and create supernaturally so the true story of God's plan and purposes is revealed. This is a time when we can not only redeem the arts and media, but also bring glory back to the Creator and see our gifts and talents bring restoration. Not only are we to use our gifts, we are to partner with others, as Rick is partnering with Christy, so that together, through excellence, we can reveal the raw power of God to the nations. Rick had a vision of touching Israel with the message of redemption in a way that speaks louder than words. Carol has an excellent clothing line, which women began to mar-

ket to transform women and the poor. My hope is that their legacy as forerunners captures our hearts and propels us forward into transforming culture.

## Dream a Little Dream

Let's envision God's great plans for the nations. His desire is for every tribe, tongue, and nation to know His love through us. We were born to creatively see our place in this moment in history and to dream of what is possible. Think of it—God's radical story has come down through the ages because men and women valued the spoken and written word. Look at those who wrote and recorded songs that display His story and His works. Artists have sculpted, drawn, and painted works of art under the anointing that reveal God's presence. Designers have woven beautiful tapestries and clothing that have held spiritual meaning. Each one of them has sacrificed for a future generation. They had us in mind.

> **We were born to creatively see our place in history and dream of what is possible.**

Take some time and envision what you would like to give to the future of humankind. What do you have that could end child soldiering, sex trafficking, abortion, or poverty? Who could you partner with, and how would you like to invest? What stories has God written on your heart that need to be told so that others can be set free? How can you release excellence in your field with a heart for the broken, poor, or forgotten in the world? Remember, everyone can have a part. Some of you can create pieces that intercede for

these nations, while others can mentor creative people. Businesses can find innovative ideas that can transform culture.

Creativity with the Holy Spirit will lead future generations into ways that bring His truth and light to every sector of society and the world. Find your place and begin to move forward so others can follow!

## Global Creativity Exercise

*Write down here the nations you feel called to touch in your lifetime.*

---

---

---

---

*Next, write down which creative venues give you passion (fashion, food, visual or performing arts, entertainment, sports, media, writing, etc.).*

---

---

---

---

*What people are doing what you would love to do, and how can you connect with them or learn from them?*

---

---

---

---

*What resources, connections, or churches could be tied to your dreams for these countries, and how can you start building bridges?*

*How could you begin to connect your dreams with what you can do right now?*

# Endnotes

1. Theresa Dedmon, *Cultivating Kingdom Creativity*, manual (Redding, CA: self-published, 2009), appendix, 126-127.

2. "Arts Shift Nations," YouTube video; http://youtube/ EA0q7JKwZBY.

3. Rick Wienecke, "Fountain of Tears" sculpture; http:// fountainoftearsdocumentary.com/about/; accessed December 21, 2011.

4. Ibid.

5. Carol Anderson; www.cabionline.com; accessed December 21, 2011.

# Are You Ready for a New Way of Thinking?

I believe the way we think about our lives and the power of God available to us needs an upgrade. Thankfully, as the word gets out, more and more people are becoming aware of who they are supernaturally and creatively, and they are seeing miracles happen in their churches, communities, and their own lives. But this awareness needs to become cellular in the Body of Christ in order to permeate society. It all starts with what we have been taught. We need to restore God to His rightful place in our view of history and our spiritual legacy. We need tomorrow to be strewn with innovative ideas because our children were taught God's plans and were able to infiltrate His core values into the systems and institutions of this world. The future is not bleak—our Dad is around to beat up every bully of religion, fear, or inferior thinking and living.

> The way we teach our children will determine the legacy of our future.

Up to this point, many of us may have taken for granted that we cannot change today's educational system. The way we teach our children will determine the legacy of our future. We *can and must* create a Kingdom culture in the way we educate our children. I believe God is raising up influential educators who are dreaming of a better way. Our present system of education was shaped by the needs and structure of industry. School subjects were chosen in a hierarchy designed to prepare children for jobs in an emerging industrial society. In this hierarchy, math and sciences are prioritized, while the arts are considered least important.

This reality is portrayed in a poignant scene from the film *Mr. Holland's Opus*. Mr. Holland, a high school music teacher, finds out that his program has been cut. The Vice Principal says to him, "I care about these kids just as much as you do. And if I'm forced to choose between Mozart and reading and writing and long division, I choose long division." Mr. Holland replies, "Well, I guess you can cut the arts as much as you want, Gene. Sooner or later, these kids aren't going to have anything to read or write about."[1]

The industrial model also encourages conformity and consistent performance defined by fairly narrow criteria. Thus, children are stigmatized for being different and are forced to comply with what schools deem as "the best." For instance, kindergarteners are now being interviewed for certain academic merits and feeling the pressure to perform well. Since art, dance, drama, and other creative forms are on the whole considered superfluous, children do not have many advocates or champions to raise them up in these areas.

## Why Do People Doubt Their Creativity?

Sir Ken Robinson, a renowned author and lecturer, has repeatedly spoken out about this issue and believes that "Creativity is as important as literacy, and we should treat it with the same status."[2]

He feels that all children have enormous capabilities and creative talents that our society squanders because we have trained them to think of their destiny through our perception of what is valuable. Pablo Picasso said, "All children are artists. The problem is how to remain an artist once he grows up."³ This reminds me of the story about the girl who was drawing a picture and the teacher came up and asked her what she was drawing. She responded that she was drawing a picture of God. The teacher gently responded that nobody knows what God looks like. The girl didn't blink an eye and blurted out, "Just give me a minute and they will!"

Robinson believes that children aren't afraid of risk and will take a chance on being wrong. If you are not prepared to be wrong, you will never have the freedom to come up with anything original. Our current system chastises those who make mistakes and rewards those who give the right answers from the textbooks. The result is that we are "educating children out of their creative capacities."⁴ We are getting students through the educational system without celebrating diversity of gifts, exploring varied learning styles, or helping each child become great based on who he or she is. And for the most part, they won't embrace this process later on in life because they have been programmed to fear failure!

I passionately desire everyone alive to feel free to create without the fear of being imperfect. At Bethel School of Supernatural Ministry, we teach students that they aren't ready to graduate unless they fail at least three times. We are not talking about moral failure, but about breaking free from the spirit of perfectionism many have learned in their educational and religious backgrounds. When I teach people to create in God's presence without fear of making mistakes, many weep because they have never been given permission to explore their own creative style without thinking that it's not good enough to meet a deemed standard no one can meet!

Sir Ken Robinson believes we have tried to reform a system that is fundamentally wrong and that what we need is not reformation but revolution. And the first challenge is questioning what most of us have taken for granted. The words of Abraham Lincoln, in addressing the need for revolution when he faced Congress concerning the threat of imminent war over the issue of slavery, are relevant here:

> The dogmas of the quiet past are inadequate to the stormy present. The occasion is piled high with difficulty and we must rise with the occasion—not rise to it but with it. As our case is new, so we must think anew, and act anew, we must disenthrall ourselves, and then we shall save our country.[5]

**Our message of God's goodness is big enough to topple any mindset in the past that has kept God inactive, unreachable, and not powerful.**

As David rose to the challenge and taunts of Goliath while the armies of Saul were quivering in their boots, so must we rise against the monolithic system that is enslaving our children with false limits and identities. We must rebuild education upon the foundation of a grace culture that allows God's creative nature to flourish in His sons and daughters and frees them from the tyranny of not being perfect. Our message of God's goodness is big enough to topple any mindset in the past that has kept God inactive, unreachable, and not powerful. The way we think about God and His goodness will restore our ability to risk trying something new and make room for

champions like David to emerge in our schools and churches. We need to train our sons and daughters to be dreaded warriors!

Robinson believes that "human communities depend upon a diversity of talent, not a singular conception of ability...[The] heart of the challenge is to reconstitute our sense of ability and intelligence."[6] I propose that this belief is not only supposed to resonate in our halls of learning, but also in the Body of Christ, where we allow people who are different than we are to flourish.

We are about to see Romans 12 and First Corinthians 12 realized, where the whole Body begins to function and work together for the common good. This starts with allowing people to create things in worship, in the marketplace, and in their hearts that look different than past generations. We have to allow the dreams of our children to flourish and give them wings to fly—even if they are different than the way we live or think. Let's start a revolution of love where children and adults in the Body of Christ and in our educational systems know that discovering who they are and what they love is more valuable than conforming to the masses. If they don't feel comfortable to risk and try, they will never find out who they were truly meant to be.

## What Do You Think About When You Think of Creative People?

As we change the way we think and give children and people in the Body of Christ freedom to explore their creativity, we also must look at commonly held beliefs that keep creative people down. Every one of us flourishes from words of encouragement and honor and is diminished by the lack of affirmation and by critical or demeaning words. In education, this is known as the Pygmalion Effect. Robert Rosenthal and Lenore Jacobson, who coined the term *Pygmalion Effect*, defined it this way: "When we expect certain behaviors of others, we are likely to act in ways that make the expected behavior

more likely to occur."[7] In other words, it is a form of self-fulfilling prophecy. It is a tragedy when we label people, either subconsciously or consciously, and withdraw honor and respect because we cut them down in size and limit their potential.

I believe that many people have wrongly labeled creative people and set them up to fail. For instance, if creative people want to pursue a career in the visual or performing arts, they need to find others who can train them. Many choose to go to the hubs of society where they can get the best education and experience, but they are often warned against this: "Do you know how many failed marriages there are in that place?" "Do you know how hard it is to get into that business?" "You really can't make any money if you pursue these dreams. I would get a 'real' job and profession." We can withdraw happiness and fulfillment from them with our negative thinking and words.

In doing this, we are siding with the armies of Saul and not with the spirit of David. We must train them to fight—not out of a spirit of fear of the enemy, but through God's presence and a supportive community of believers who believe in their victory! God never cared about safety in numbers, but rather passion and closeness in relationship to His presence. We will see major Christian churches and centers arise that will be a prophetic voice to the arts communities and will draw them into God's love.

Elizabeth Gilbert, author of the book *Eat, Pray, Love,* gave a talk about how labels and stereotypes have negatively impacted her life and the lives of all creative people. People believe that creative people have a tendency toward depression and drugs and are in for a stormy life. "We don't even blink an eye 'cause we have heard this kind of stuff for so long," said Gilbert.

> We have internalized and accepted collectively this notion that creativity and suffering is somehow inherently

linked and that artistry in the end will always ultimately lead to anguish.[8]

Gilbert then asked the crowd,

Are you guys cool with that idea? Because I am not at all comfortable with it! I think it is odious, and I think it's dangerous, and I don't want to see it perpetuated into the next century. It's much better to help these creative minds to live.

Gilbert believes this pressure came upon creative people during the Renaissance:

Let's put man in the middle as the center of the universe, which is called rational humanism. They thought creativity came from the self, negating any other divine source.[9]

In her estimation, this emphasis left out divine inspiration and influence, which promoted pride. She believes that as a culture we need to erase this humanistic thought that has plagued humankind for the last 500 years. I couldn't agree more. God needs to come back as the center of inspiration—not us. The only assumption I disagree with in her thinking is that this divine inspiration comes from a nebulous divine, rather than from the great I Am.

**Doubting the love and the gracious nature of our Father creates a poverty mindset.**

We also need to see a revolution from a competitive to a cooperative paradigm in our society and educational system through the

revelation of our identity as sons and daughters of God. If we are constantly comparing what we have to others without understanding that we have the same spiritual Father, we will become critical and small in our thinking. Doubting the love and the gracious nature of our Father and what we have already been given creates a poverty mindset and leads us to act like we are paupers, when we are already royal through spiritual adoption.

This poverty spirit can be seen in the elder brother of the prodigal son. The elder brother angrily refused to come to the party his father had set up to welcome his prodigal son home, complaining that his father had never done that for him. The father rebuked him, reminding him that everything he had was already his (see Luke 15:25-32). If we compare our gifting and anointing to others and cannot celebrate their successes, we are partnering with the enemy. Rather, we should bless those who are recognized because we are secure in our heavenly Father's love for us, which is greater than any success or approval from people. If we are going to change the major spheres in this world, we must be able to work together, let others grow farther than we have, and let them stand on our shoulders, like Jesus does.

We also must be able to see God's influence as greater than the enemy's. The last time I checked the Bible, the enemy loses and forfeits everything. When we believe that advancement is too hard or that bringing the kingdoms of the world into the Kingdom of our God is too great a task, we are limiting our perception to our own ability and foresight.

Remember what happened when Moses sent 12 spies ahead of Israel into the Promised Land? When the spies returned home, they brought back the fruit of the land, declaring its bounty. The children of Israel get excited, until ten of the spies started to paint a picture of the giants and cities they would need to conquer. They started to use conjecture and comparison, which led to doubt. In

contrast, Caleb and Joshua had complete confidence in God's ability, which had saved them in the past. Yet, the majority naysayers were the most influential: *"We can't attack those people; they are stronger than we are"* (Num. 13:31b NIV). Because of the fear in their own hearts, the ten spies began to spread this rumor, keeping the Israelites from faith and entering the Promised Land for another 40 years.

Many Christians have been afraid of the Promised Land that has already been given to us through the blood of Jesus. Our Promised Land lies in the spheres of society where we now have favor. Even though there may be evil, factions, or tall giants in the land of our anointing, we must have the spirit of Caleb and Joshua. We must have our eyes opened to see the armies that are for us, not against us (see 2 Kings 6:17). Our destiny lies in aligning our faith with God's desire to creatively position us for favor both in our call and in the sphere that we were born to influence. Let's look at a few believers who have influence in different spheres and who have a spirit like Joshua and Caleb.

## Kingdom-Minded Strategies in the Business Realm

My friend, Valerie Greco, finds ways to bring Kingdom core values into her business, which are transforming her workers and her company. Here's her story:

> When God gave me a position as a leader in a health-care business, I was unaware of the challenges that I was about to face. I began to ask God for strategies to win my staff's hearts and change my environment. After a month of working with them, I made a card for each person and wrote a prophetic word about each. Many came to me and thanked me for the note. Then I began to teach them how to bless our business by blessing other depart-

ments. I brought in candy and told them to pick someone out who really helped them and give them a treat while speaking encouraging words. One staff member said begrudgingly, "Well, if you really want us to, we will." I said, "Yes, please try."

It has become such a part of our culture that now I hold a raffle every month, and my staff are picking out people and writing others' names on tickets for the grand prize. They love to choose a ticket out of the basket and celebrate whoever wins. I also do random things for my staff like purchasing peppermint patties and cutting out little notes that say "Thank you for refreshing and healing others." This casts vision and encourages them to continue to serve. I also have a laughter group and a soaking group for our clients. I have seen God do some miraculous things as these groups take place. Our rating as a business has doubled in the last year. We went from a 2-star rating to a 4-star rating in just over a year's time.

Valerie could have looked at the giants she faced in her position, but instead, she brought honor, encouragement, and team spirit to her company, which radically blessed the employees and increased overall ratings! When we creatively ask the Holy Spirit for ways to bring His Kingdom into the places where we work or live, everyone will benefit!

> **We can look at the constraints around us instead of focusing on the creative possibilities that lie within our grasp.**

So often we look at the constraints around us instead of see-ing the creative possibilities that lie within our grasp. We need to change the way we think, ask the Holy Spirit for creative strategies, and then see Him work. Michelle Diablo, a teacher in Ohio, heard about the core values of Bethel and began to creatively apply them to her classroom. Here are just *some* of her *amazing* testimonies!

> In my classroom, my students and I discuss the power of honor, relationship, and the power of our words and our actions. We also speak to the core values that have been established in our classroom—respect, integrity, trustworthiness, responsibility, caring, and citizenship. Culture Club is the name we have given ourselves over the years to represent the things we do that change the culture in our school. It is impossible to recount all that God has done in my classroom and school throughout the years because He is always doing new things!

> The following is an example of Heaven invading our public schools: My students participate in Treasure Hunts in our building. I adapted the Treasure Hunt form from Kevin Dedmon's book and made it applicable to a school setting. As I play Christian instrumental music in the classroom, students write down what comes to mind. Then they take the letter we wrote as a class and a piece of Hershey's Treasure Chocolate and go hunting! They are so thrilled to tell the class about their treasure. Students have come back after holiday breaks saying their treasure was a relative sitting at their Thanksgiving table.

Michelle has adapted a model that works in a non-Christian set-ting and is changing lives. You may ask, "How can this happen?" Well, Jesus went into the streets and spoke in parables, and the

people who were open understood. We need to be creative in our approach; we need to be relevant and relatable and to express the core values of the Kingdom. Here is an example of how Michelle teaches the students on the power of forgiveness and words:

> Each year I have students meditate on a person they need to forgive. Students write down his or her name and their memory of this experience. Afterwards, students close their eyes and are encouraged to release that person for the hurt he or she caused. Students take their paper and throw it in the trash... smiles light up the classroom as students feel freedom. After teaching about the power of our words and thought life, students write a book using the theme "The Power of Words."

Finally, Michelle brings her core values into her workplace by encouraging the other teachers. She writes encouraging words about the power of teaching and drops them in the teacher's boxes.

## What Can I Do?

One of the most liberating truths that we will ever experience is found in one of the shortest verses in the Bible, "...*Christ in you, the hope of glory*" (Col. 1:27). We *can* make all of the difference to those around us because Christ lives in us! This profound thought needs to not only change the way we think, but also the way we live. God has planted a destiny inside you and given you influence with God and with people so that His supernatural power can flow through you. Your unique factor, your dependence on His nature and creativity, and your hunger to see others transformed will make you into a Caleb in your generation. If you ask God, He will open your eyes to so many creative ways that you can bring healing, Kingdom core values, and love to others.

**Christ in you will radically transform whatever you touch or create.**

He really doesn't care if you are president of a company, the mother of two, or a college student—Christ in you will radically transform whatever you touch or create. You can reverse the curses, the limitations, and the fears that have stopped our generation from being free to be who we are and experience God's grace and goodness. You have been given the keys of the Kingdom to unlock God's goodness into every sphere of society. Change the way you think and see every problem and limitation through giant-killer eyes. You were born for this!

## Creative People Are Marked for God's Blessing

Like Elizabeth Gilbert, we need to declare life over the entire population of creative people who have been marked for divine inspiration. This is why they are sensitive and can hear His voice. They are marked by times with God's presence, as David the shepherd sought God in the midst of the night. Let's change the way we perceive their role in the Body of Christ. Repent for any negative thoughts or perceptions about creative people, both in the Body of Christ and in various professions. Have you partnered with a poverty mindset about their future? Have you thought that other professions were more valuable? Have you perceived creative people as being moody, irresponsible, or lazy? Have you categorized them as not being able to organize or follow through with projects? Do you view them as depressive and unable to deal with conflict? Change the way you think, and call out the gold in their

lives. Just as you don't like it when others put you in a box, don't conform others to misperceptions you have. Like the ten spies, we can say things over people that influence them negatively. We can create negative, self-fulfilling prophecies that they can misperceive as truth about who they are! Their spirits can give in to the negative labels people have given them, siding with hell instead of Heaven. Jesus came to give life, and that more abundantly, and we need to do the same!

Take some time and repent if you have subconsciously agreed with any wrong thinking or belief that is not Kingdom-based. Creative people are not going to be this way in Heaven, so let's not put chains upon them down here! Let's agree with what Heaven says about them, valuing their sensitivity and seeing the prophetic nature it can bring. Likewise, if you have been on the receiving end of these negative perceptions and words, forgive those who have hurt you. Now is the time to break the chains that have held you back from your true destiny. You may also need to forgive teachers, parents, spouses, or other people who have labeled you negatively because you are creative! This is your time to hear the Father's blessing over how He made you!

## Declarations

Begin this redemptive work by sealing your thoughts with declarations. Start making declarations every time you see a creative person and over yourself until your spirit automatically agrees with Heaven. Take advantage of all the opportunities to make declarations when you hear music, watch movies, and see artists create. As you declare, then begin to see those artists and yourself walking as true sons and daughters. Agree with Heaven that creative people will collaborate with the Holy Spirit and create great works of art that will express the Kingdom. Affirm that God will grant them success with God and people and that they have every right to fulfill their dreams. Declare that God will bless them in marriage and that

their children will prosper and feel secure. Agree that there will be a legacy of goodness, purity, creativity, and joy that will follow them all of their days. Embrace them in your community and declare that they will find value in the Body of Christ. Ask for godly men and women to be sent who will strategize with them and help counsel and guide them as they pursue transformation.

I am going to present you with a declarative reading, which I would like you to copy and place in a strategic place, adding in your own words, so that you can partner with the Holy Spirit as well. Every time you go to the movies, watch and pay for your cable television, rent DVDs, buy music on iTunes, or see entertainment—as you give your money or watch programs—I want you to partner with Heaven so that we can see creative people transformed. At Bethel Church, we have offerings readings, which we declare as people give back to God. Here is one that I have revised to be pertinent to changing the way we think about our creativity and what is possible through creatively declaring God's Kingdom, creative people, our influence, and the arts:

## Declaration Exercise

*I pray for Heaven to come on earth and for Kingdom creativity to transform my city. Lord, I ask You for my gift of creativity to flourish, thanking You that I was born to create.*

*I declare Kingdom creativity in arts centers to produce images, entertainment, and writing that build faith and impart life.*

*I declare heavenly revelation for inventions, strategies, and ideas that answer questions the world is asking.*

*I ask for presence-based arts that impart Heaven's creativity and supernatural power.*

*I declare arts that build Kingdom mindsets and influence the influential.*

*I ask for favor for artists with editors, producers, and publishers.*

*I ask You to develop leaders, teachers, and parents who encourage creativity, imagination, and ideas.*

*I repent for a poverty mindset, independent thinking, and hopelessness over the arts community and myself.*

*I see artists known for healthy connections with family, community, and God.*

*I declare godly creative communities marked by integrity, generosity, and love.*

*I declare the media will be known for reporting truth and finding the good in the news and in people's lives.*

*I see new provision, strategies, and resources to create and invent things that will end the crisis and problems in our day.*

*I declare renewed imagination to find strategies for new businesses that showcase the arts, create new jobs, and provide services, so that no artist will go hungry.*

*I declare people will be free to create, to explore different ways to use their imagination, while partnering with the Holy Spirit.*

*I ask for risk and courage to recognize opportunities and make them happen.*

*I ask for more abundance to benefit the world through creative ideas, which can be stewarded and grown.*

*I declare that this generation will rewrite history through dependency on the Father, and that all of God's cre-*

ative people are the happiest and most fulfilled people on planet Earth.

I ask for revelation to educate and raise up the next generation to walk in who God has designed them to be, using their giftings and talents, being free to choose the path they love, because we believe in them.

We declare that where creativity flourishes, religion runs and freedom abounds!

Thank You, Creator God, that as I join my creativity to Yours, You will shower FAVOR, BLESSINGS, and INCREASE upon me so that I can bring Heaven to earth and promote the Gospel of Jesus Christ.

# Endnotes

1. "Mr. Holland's Opus (1995) - Memorable Quotes" *The Internet Movie Database;* www.imdb.com/title/tt0113862/quotes; accessed December 21, 2011.

2. "Ken Robinson says schools kill creativity," *TED: Ideas Worth Spreading* (February 2006); http://www.ted.com/talks/lang/en/ken_robinson_says_schools_kill_creativity.html; accessed December 21, 2011.

3. Pablo Picasso, quoted on *BrainyQuote.com;* www.brainyquote.com/quotes/quotes/p/pablopicas169744.htm; accessed December 21, 2011.

4. "Ken Robinson says schools kill creativity," *TED: Ideas Worth Spreading.*

5. "Sir Ken Robinson: Bring on the learning revolution," *TED: Ideas Worth Spreading* (May 2010); http://www.

ted.com/talks/lang/en/sir_ken_robinson_bring_on_
the_revolution.html; accessed December 21, 2011.

6. Ibid.

7. "The Pygmalion Effect," *Duquesne University: Center for
   Teaching Excellence;* http://www.duq.edu/cte/teaching/
   pygmalion.cfm; accessed December 21, 2011.

8. "Elizabeth Gilbert: A new way to think about creativity,"
   YouTube video, 19.29, posted by TEDtalksDirector
   (February 9, 2009); http://www.youtube.com/
   watch?v=86x-u-tz0MA; accessed December 21, 2011.

9. Ibid.

# Finding Your Place in History

I believe the Body of Christ has the power to build a container to host God's presence so that the glory of God will spread all over the world, breaking the power of the enemy and opening all eyes looking for Jesus. This is our destiny. All of creation is longing for the sons and daughters of God to be revealed (see Rom. 8:22-25). Nature responds to God and to His voice, and He has given us stewardship over the earth. We are on earth to bring transformation in so many ways that we have yet to understand because we carry the breath of the Creator inside of us.

> God desires excellence from you, but doesn't put you down when you make mistakes.

I want to encourage you to identify God as your Father and yourself as His precious child. The King of kings has given you honor, and He bids you to come and be seated with Him in heavenly places so that you might know His grace and kindness (see Eph. 2:6). Right now I bless you with the understanding that God has provided an acceptable sacrifice and made you worthy through His blood. I bless you with the understanding that God desires excellence from you, but doesn't put you down when you make mistakes. You no longer have to earn a position of favor or try to feel accepted by Him because you already *are!* There is nothing you can do to make Him love you any less or to make Him love you any more. His love is perfect for you! Your best would never be good enough to earn His love. I bless you with the understanding of how profoundly, at this moment and for all of eternity, God loves you.

I once did a simple painting with a black background and a single blood-red iris attached to a green stem sticking out of a bright yellow base. I entitled this painting "Enough." It symbolizes the stark beauty of Christ's sacrifice, which alone can bring us life. The red of the iris symbolizes Christ's blood shed for us so that we may receive new life through our connection with Him, just as the green stem is connected to the iris. In this, we find our joy, represented by the color yellow. Jesus, *"for the joy set before Him endured the cross"* (Heb. 12:2 NIV) so that we could have new life through Him. My prayer was that every time someone saw this painting, it brought home this simple, but profound, message that His blood is enough. It is all that we need. It is the starting and ending point of our story and our message.

Some time ago, I went to South Africa and spoke at different churches about the power of supernatural creativity. During a Sunday morning service, I showed them a slide show illustrating the power of creativity and this painting of the iris came up. All of a sudden, I knew there were angels in the room sent there on assignment to open people's eyes to this simple yet profound truth. I began

to talk about the power of His sacrifice and that it is a finished work that completely frees us of guilt, shame, or fear of punishment.

At that moment, I knew that I could continue on or be led by the Spirit. So I abruptly stopped and in the middle of the service, through a painting describing His sacrifice, 12 people stood up and received the fullness of Christ's atonement. Shortly after this, another wave of His presence came, and people were filled with the Holy Spirit all over the room, and they received spiritual gifts. I then had the people in the congregation prophesy over each other. At the end, I watched people who had never seen anyone healed before pray for those who were sick, and 25 people were healed! God is good! A message encapsulated in a simple image I painted in God's presence brought many into encounters with the living God. It's so important to stay close in dependency upon the Spirit to find out creatively what is next.

Many of you who have been reading the testimonies in this book and learning about the power of love and the supernatural may still be plagued with fear, shame, guilt, or feelings of unworthiness, both in relationship to God and what you create. Now is the time to be set free! All you have to do is repent from wrong thoughts about who you are and let Christ's blood cleanse you deep inside. It doesn't matter how many years you have gone to church or if you have studied the Bible from cover to cover—if you don't feel loved by God and if you don't feel His grace over every area of your life, you are living below the line of being His son or daughter.

Many times we think we have done something so wrong that we still have to pay for it through guilt and shame. We may feel like a disappointment because of marital strife or other issues. So, I ask you now to pray a simple prayer, repent, and agree that the Father has good things in store for you! No matter what anyone else says or no matter what circumstances may say, you *are* His beloved!

*"For I know the plans I have for you," declares the Lord, "plans to prosper you and not to harm you, plans to give you hope and a future"* (Jeremiah 29:11 NIV).

If you are not living with hope in every area of your life, then it's time to apply the redemptive blood of Jesus to your life and receive the goodness of His grace!

When the Prodigal Son returned home, his father came running to meet him. The first words out of the son's mouth were, *"I am no longer worthy to be called your son"* (Luke 15:21 NIV). In order to break this lie off of his son, the father didn't argue with him theologically. Instead, the father put his best robe on him, put his ring on his son's finger (signifying that everything he had was now his), and put sandals on his feet. Then, they killed the fatted calf—in other words, the father told everyone to have filet mignon and party! The ring restored everything that was lost! I believe so many of us live our lives without knowing what the Father's robe of acceptance feels like, and we have not placed the ring of inheritance on our hands because we still are thinking like paupers. Take some time and put yourself in this story. Let the robe be placed on you and the ring be put on your finger. All of Heaven celebrates you! For more on this subject, I encourage you to read the book, *The Supernatural Ways of Royalty* by Kris Vallotton, a spiritual father to many in the Body of Christ who have never fully understood sonship.[1]

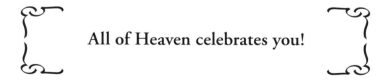

**All of Heaven celebrates you!**

## What Holds You Back?

Once we know we are in God's family and are brokers of Heaven, we need to walk in the fullness of that inheritance. This means

that every thought, every attitude, every belief, and every action that does not line up with Heaven has to go. Bill Johnson says, "I cannot afford to have a thought that didn't originate in the heart of God." This means that we have to break our alliance with the enemy and break off any agreements we have had about ourselves and our destiny that are not Kingdom-oriented. As we step out and go for our dreams, we find out what we really believe.

We need to honestly ask ourselves, "If I go for my dreams and don't succeed, am I a loser? Have I let God down? If I create something and someone criticizes me, am I going to stop creating?" We have to come to the realization that we determine our own destinies by the choices we make and what we believe. God has given us a free will, and He will not violate it. Circumstances in life shape our destinies. If we see our lives from God's perspective, we cannot lose! Every circumstance in our lives has a seed of redemption, waiting for us to discover. Every fear we face will give us anointed authority.

Kris Vallotton says, "The dogs of doom stand at the door of destiny." In other words, fear is there to keep you from opening the door to who you truly are and what you are called to accomplish. We have to look throughout history and realize that everyone who has made a difference took a risk. They weren't afraid to fail! Aren't you glad that Thomas Edison didn't give up after his first try at making electricity! We have to be aware that the process of moving into our destinies through creativity will not be perfect, but will carry revelation along the way! We will find out what we really believe about ourselves and what holds us back.

Constraints can come from internal struggles, outside circumstances, or people. Many people have struggled to write, paint, dance, or create in different forms because of a teacher, parent, friend, or sibling who criticized them. When we agree with people's negative assessments of who we are, we can put ourselves in a box of

offense, which may lead to self-hatred. We are conforming ourselves to a different standard than what Jesus paid for.

> *Do not conform any longer to the pattern of this world, but be transformed by the renewing of your mind. Then you will be able to test and approve what God's will is—His good, pleasing and perfect will* (Romans 12:2 NIV).

We cannot see His redemptive plan in all of our circumstances until our thoughts have the pattern of His thoughts—not the thoughts others have spoken about us in a negative light, but *His thoughts.*

> **The change came fully when I saw how much I had to gain by being free, which made me willing to pay the price to change.**

## Facing Constraints

Let me illustrate this point from my own life. I was painfully shy all the way through high school. I hid behind a wall of fear that literally strangled me, especially when I met new people. I remember my knees knocking as I recited a poem I had written in high school—I can still see my paper shaking as I gulped back terror. I was confident in writing and had won many awards, but still was terrified to speak publically. This constraint affected my self-worth and my ability to make friends. But there is always another side to the coin. This constraint also brought me close to Jesus because I needed Him so much! I found Jesus as my close friend in a place where I felt insecure around others. As my belief in His love for me grew, I gradually became free of this constraint. The change came

fully when I saw how much I had to gain by being free, which made me willing to pay the price to change.

After I graduated from college, a Vineyard church asked me to come on staff as a pastor. I was shocked! "Who, me, who can't communicate well? Are you sure you have the right person?" I literally thought that way! And then the Lord spoke to me and assured me, "Theresa, you are *perfect* for this position. Other people may rely upon their strength as communicators, but you will rely upon Me." And with those words, I was free to be who I am! Please believe me, it has not been an easy transformation. I have forced myself into situations to gain more confidence. I oversaw the welcome ministry at the Vineyard because I wanted to conquer this constraint. Now, when people see me, they can't believe I was ever shy. I am thankful for this experience because it taught me that with God anything is possible!

Kingdom creativity can only be accessed in an environment of freedom. Be willing to pay any price to be set free from what hinders you, and go after freedom until there is victory. I needed to change the way I saw myself and to put myself in a position where I could practice being free by facing my worst fears.

Before you read farther, I would like you to take some time and get alone with God. Ask Him what holds you back from your destiny. Examine your belief patterns, habits, or actions that are not aligned with the heart of the Father. Write them down. Now, begin to ask yourself what your life would be like if you *didn't have* those constraints. What would you be doing? How would your quality of life improve? How would you think differently about yourself?

If there are any constraints or lies holding you back, ask yourself if you would like to continue to live the way you have been living or if you would like to be free from these constraints. If you said yes and want freedom, you have taken the first step. Repent for how you

have partnered with the enemy in believing that this is who you are and nothing will ever change. Ask God to forgive you. After you do this, ask Him to reveal to you your true destiny and who you are. Ask Him to show you what gifts He has given you to replace the constraints. Let Him fill you with His love!

After you do this, write out a declaration about who you are and what you will believe and live by from now on. For instance, in my situation, this is what I would write.

> Theresa, you are not a coward; you are courageous! You have the Spirit of God living inside of you and what you say matters to Him and matters to others. You are free to communicate, laugh, and share your heart because you are valuable and you are made in God's image. Fear is not your friend, so make a choice not to listen to that voice. You have peace and ease in every conversation. You have something powerful to share that no one else has said. You already have the victory—now walk in it.

> My Declaration:

You may have to say this every day for a while until it becomes a natural part of your lifestyle. Circumstances don't determine how far you go. You determine how far you go by how much you let God

into your pain and praise Him for the victory. As these declarations take shape around your life, the robe of the Father is draped securely around you.

After this, take some time and match Scripture with whatever constraint you are breaking. In my case, the verse *"God has not given me a spirit of fear, but of power and love"* helped me to counteract my constraint with the truth of God's Word (see 2 Tim. 1:7). Another promise was Joshua 1:9: *"...Be strong and courageous. Do not be terrified; do not be discouraged, for the Lord your God will be with you wherever you go"* (NIV). The declarations of Scripture are the filet mignon at the Father's banqueting table!

> *You prepare a table before me in the presence of my enemies. You anoint my head with oil; my cup overflows. Surely goodness and love will follow me all the days of my life, and I will dwell in the house of the Lord forever* (Psalm 23:5-6 NIV).

Let's feast on the goodness at the Father's table and not settle for living in a cage of fear any longer!

## Power of Action

I believe many people stop here, which is why their constraints never completely leave. You need to implement an action plan with those declarations and Scripture and learn to overcome. If I had repented, declared, and prophesied Scripture over myself and then stayed in my room, nothing would have changed. I had to face my fear head on! You have to begin to do the thing that has terrified you, whether it's to speak, to sing, or to create. Whatever it is, as you do it, you will become free. Remember the testimonies about people who painted and were freed from performance issues or fear of people? The more you actively face what you fear, the more the fear will dissipate and become your greatest strength! Take a moment and write down what you could do every day or week to face your fears.

> The more you actively face what you fear, the more the fear will dissipate and become your greatest strength!

We have to deal with constraints and distorted thinking before we can walk in our creative callings. Until we do this, we will always go back to our old ways of living because everyone needs to be true to who he or she truly is. If you don't feel like you are a great speaker, and your thoughts sabotage your attempts at speaking, you will eventually give up. So make sure that you face your fears, repent, declare, and walk in your destiny.

## Review: Passions, Gifts, Talents, Anointing, Calling, and Sphere of Influence

God has designed us with certain desires that come to the surface during our lives. They show up in the movies we like or the songs we listen to or what we loved to do when we were younger. They are the things that give us pleasure—hobbies, business pursuits, and various creative expressions. Passion is important because if we are not motivated to pursue something, we will lose interest.

We also all have natural gifts that can be developed with effort and stewardship. Jesus gave us the Parable of the Ten Minas, in which a rich man gave away minas to his servants, expecting them to put the money to good use and invest it while he was away (see Luke 19:11-27). On his return, one of the servants brought back a ten-fold reward and was put in charge of ten cities. Another invested, received a five-fold increase, and was awarded governance of five cities. The third servant hid the mina because he was afraid of the

master. When the master heard about the one who buried the talent, he gave his mina to another person.

If we bury our talents and gifts because we fear God's disapproval, we will forfeit the great legacy we have been given. Our talents and our gifts are meant to glorify the Creator. It is not prideful to use what you have been given so that others can be blessed. Instead, it gives glory to the Creator by reflecting Him! God wants us to invest our talents and creativity and reap a hundred-fold reward. Gifts and talents are indicators of where we should invest our time and our energy.

Your passion and gifts are all important to God. Sometimes we compartmentalize our talents and think that some are more valuable than others or that God is only concerned with ones that are directly related to ministry. God has equipped each one of us to accomplish certain tasks through our talents, passions, and call, which if fulfilled, will all glorify God.

Take, for example, the "Flying Scotsman," Erik Liddell, who won the 400-meter Olympic gold medal in 1924 for Scotland. A devout Christian, Liddell refused to run in a heat held on Sunday because it was the Sabbath, and he was forced to withdraw from the 100-meter race, his best event. When the day of the Olympic 400-meter race came, Liddell went to the starting blocks, where an American Olympic Team masseur slipped a piece of paper into his hand with a quotation from First Samuel 2:30: *"Those who honor Me I will honor."* Not only did he win, but he broke the record. Many people, including his sister, Jenny, felt he shouldn't pursue running, but needed to be on the mission field in China. But he knew he was headed for greatness because of the passion he had developed for running. In the movie adaption of Erik's life, *Chariots of Fire,* Liddell explains his passion when says, "I believe God made me for a purpose, but he also made me fast. And when I run, I feel God's pleasure."[2] Liddell touched the sports and media sphere through his

passion, love for God, and stewardship in running, more than if he would have listened to his sister and gone to the mission field prematurely. When do you feel God's pleasure in your life?

Let's look now at anointing. The Hebrew verb *mashah* means "to anoint through smearing with oil or paint."[3] The anointing is essentially the Spirit smearing us with His presence. We are familiar with this in regard to ministry, but think about this now in relationship to creativity. God's design is to use His paint from Heaven upon what we create. As you look for your unique factor, discover what anointing God has given you. For instance, in the Old Testament the prophet Daniel was anointed to interpret dreams, which opened doors to government. Deborah's governmental anointing restored peace to Israel.

Your call is what you were born to do. Paul was called to bring Christianity to the Gentiles. Like Paul, when your anointing is connected to your call, all of your gifts and passions will be utilized. This creates a convergence where everything in your life comes together and makes sense. A call is always larger than what people can achieve by themselves.

There are many things that point to people's callings and help them discover where they are headed:

- **Feedback**: What comments have you received from teachers, friends, or family in regard to your creativity, gifts, and passions?

- **Energy:** What do you do that makes you feel more energized than when you began—even if it was physically or mentally exhausting?

- **Fruit:** How are people impacted when you are doing what you love?

- **Anointing:** Does Heaven back you up, and is there a supernatural power that flows through what you create and do?

- **Desire:** Is it something you would pursue at all costs?

- **Practice:** What are you willing to sacrifice so that this dream is fulfilled? Would you be willing to invest time, money, and higher learning to perfect your talent?

- **Longevity:** Is this a passing phase, or is this something that you see yourself doing 5, 10, and 50 years from now?

- **Creativity:** Do you burn with ideas for ways that you could grow in this?

## Who Will Be Impacted by Your Creative Call?

The next phase for finding your call will be in discovering the people you were born to reach. For instance, if you feel called to government and you are a singer, you might plan on perfecting your voice so you can sing before kings and queens. If you feel called to architectural design and Africa, you can use your creativity to build hospitals in the bush. It's important to find the place you feel called to transform, whether government, family, education, the church, arts and entertainment, media, or business.

If you are still in the "I don't know" stage, then you are in the process of discovery and need to grow in your gifts, dreams, and passions until you *"know* that you *know* that you *know."* I would encourage you to serve someone else's dream until you find your own. There are also seasons when God is having you steward your five talents before He shows you the big picture. Faithfulness is much more important than we think and will pay off big dividends in our future call.

## Supernatural Creativity Versus Plain Talent

God calls us all to prophesy and heal the sick. If we love Jesus, we must be about the Father's business, and these are mandated elements of that business. Creativity in the arts, in business, and in any of the realms listed above is likewise available to everyone. But what makes it supernatural is when you invite the Holy Spirit to collaborate with you and pursue signs and wonders. Natural talent is a gift that people can develop, but it doesn't have the power to transform others unless God's Spirit has anointed it or it is their call.

An anointed person can supernaturally partner with the Holy Spirit through his or her gift and influence thousands of people. An example of this is Harriet Beecher Stowe, author of *Uncle Tom's Cabin*. Before penning her famous novel, she wrote many articles and stewarded her gift well. She was primed and ready for the opportunity that would launch her into worldwide fame. Consumed by the evils of slavery, she had a vision in her church pew of scenes in the book. She wrote and submitted it, and by 1852, it had swept across America. When she greeted Abraham Lincoln, it is alleged that he greeted her with the words, "So you're the little woman who wrote the book that made this great war!"[4] Like Stowe, who sowed into her writing for years before God gave her the vision and the favor to write the book that transformed our American culture, we grow in favor with God and people by *stewarding our gifts* through regular practice and growing in excellence. We need to ask God for *the right connections* and people who can help us grow in skills, and we need to *walk in character*. We are a family and will find our place in the context of *community*. Then, we need to grow in *our relationship with the Holy Spirit,* looking for people to *supernaturally* minister to through our gifts. Lastly, we need to continue to *deal with the constraints* that keep us from fulfilling our creative destinies and believing who we truly are. As we do this, we will find our place in history.

# Finding Your Place in History

If you have not already, take some time to journal about the following areas:

## Passion

*What are you passionate about? What do you really care about? What would you live for? What would you die for? What would you like to pursue but are unsure if you would be any good at—what are your hidden passions?*

_____

_____

_____

_____

## Gifts and Anointing

*What do you do well? What are your strengths? What are your gifts? What is the talent, the uniqueness, that sets you apart from everybody else? When do you feel the most anointed?*

_____

_____

_____

_____

## Indicators

*What direction do you think these indicators (your passions, giftings, and anointings) are leading you to pursue to fulfill your dreams?*

_____

_____

---

---

### *Sphere and People Groups*

*What sphere do you feel called to (arts and entertainment, media, church, business, education, government, or family)? What type of people would you like to reach in your life?*

---

---

---

---

### *Supernatural*

*What supernatural impact do you want to make in history through your creativity and influence?*

---

---

---

---

### *Constraints*

*List your constraints. How could you work on these so that you will be propelled into your destiny?*

---

---

---

---

*Write down some first steps that you want to pursue this month in walking out your call.*

_____

_____

_____

_____

## Endnotes

1. Kris Vallotton, *Supernatural Ways of Royalty* (Shippensburg, PA: Destiny Image, 2006).

2. "Chariots of Fire (1981) - Memorable Quotes," *The Internet Movie Database;* http://www.imdb.com/title/ tt0082158/quotes; accessed December 21, 2011.

3. *Strong's Exhaustive Concordance of the Bible,* Greek #4886.

4. Daniel R. Vollaro, "Lincoln, Stowe, and the 'Little Woman/Great War' Story: The Making, and Breaking, of a Great American Anecdote," *Journal of the Abraham Lincoln Association;* http://quod.lib.umich.edu/j/jala /2629860.0030.104?rgn=main;view=fulltext; accessed December 21, 2011.

# What's Next?

L ike a surfer searching the horizon of vast water for the perfect wave, we must be able to see what's ahead in the spiritual dimension so we can catch the wave of His presence and ride into His purposes and plans. I believe God is getting ready for a great harvest. You and I must be in the water searching, and yes, learning to ride. We have to learn to trust our own instincts in catching a wave, and most of all, we have to *love* being in the water of His presence.

I remember watching my son, Chad, surf for hours down in Huntington Beach, California. It didn't matter how flat the water was or how stormy the clouds were—nothing could deter him from being out there. How motivated are you to continue to ride until you catch "the big one"? If God has already given us the keys to the Kingdom, then the wardrobe door to discover limitless impossibilities has already been opened by others who have ventured inside. We need to be supernaturally creative, Spirit-led junkies who keep creating, searching, and exploring God's vast plans until we catch our wave and find our place in history.

*Stay the Course*

Let's face it: We are never going to get there unless we learn to risk. And once we catch our wave, we have to learn to stay in the right position; otherwise, we can get buried in the wave. Getting to our wave and staying on it both require the power of "staying the course." When Walt Disney shared his dreams about Disneyland, everybody thought it was ludicrous and ridiculous. Over 300 bankers turned him down. But that didn't stop a man who, through faith in prayer, saw the wave of goodness he wanted to ride. He wouldn't let go until he finally found someone who would fund his vision. If Disney had been a reasonable man who accepted other's limited views about his dreams, just think of all the children, families, and people who would have missed out. Decide now that your dreams are *valuable and worth pursuing. Forget being reasonable or practical and go with what is impossible!* Faith is made up of believing in what we can't see, but know will be—even when it doesn't make sense.

**Focus determines our progress towards fulfilling our dreams.**

One of the greatest hindrances to progressing toward our dreams is that we give up too soon because we have the wrong focus. We listen to the naysayers, like Israel did to the ten critical spies, which kept them out of the Promised Land. We have to focus on God's supernatural power at work inside of us. Bill Johnson never detoured from his vision of revival, even though many thought he was crazy. Now Bethel Church is a hotspot that equips so many others to follow their dreams. Opposition only makes us stronger and solidifies our resolve. When opposition hit the early church, they just became bolder! Our focus has to be on using all

of our gifts, anointing, favor, and position to be a supernatural instrument for God's Kingdom to be established now. Your loaves and fish can feed more than 5,000 because they have been blessed in His hands to feed the hungry.

## Where Is Your Heart?

Personally, I can't wait to see everything I have been given transform society as I am given favor through being with the Father. It started in seed form when I was young and decided to give my testimony to prisoners at the Nevada state prison—even though I was trembling in fear. It grew as I went on to pursue my degree from Bible college and took on positions in churches. I was impacted by seeing how many children were lost in Los Angeles as we did events with crossover music in large venues in the inner city. It was during these events that I began to come up with creative ideas for ministering to the children. I had nothing but compassion because I saw the need. Focusing on the needs of others around you, if you open up your heart, will lead you to do impossible things!

Now I have the privilege of transforming people all over the planet, setting them free to dream, be who they are, create their own legacies, and learn to use their gifts supernaturally to transform culture. It started with risk, fueled by compassion, and now it is influencing others. I love to ride the waves! At times I have been toppled, dragged under by swift currents to the point that I don't know which end is up, but eventually I have always found my footing, gotten up, and looked back to the horizon. I am hungry for adventure. I am hungry for the chance to change history, because I know who is riding with me, and He will always be there. His dream, as I have shared before in this book, is that we would do greater exploits then He did on the earth! So focus on what you have, ask for the impossible, stay close to the Spirit, and see the needs that stir your heart be fulfilled in your lifetime. Start with one step, move forward—and never look back.

## Explore Creativity and Innovation

Anyone can learn to ride the waves with the Holy Spirit—even those you would least expect. A friend of mine, Chris Evans, works with Hope for Homeless Youth in Los Angeles, California. Many of us have the stereotypical view that the homeless have nothing to offer, but this is not what God thinks! Thankfully, others are not limited by what society values, but are in tune with God's estimation of life. Part of the discipleship program for these homeless youth is training them to soak in God's presence by praying in tongues for an hour. As they do this, they are challenged to come up with innovative ideas and witty inventions that will shift our economy. God's presence is birthing innovative ideas within the homeless! So far they have received nine patents for their inventions, with others pending. They ask for technology from Heaven, calling it the "Inventor's Club." Business speakers come to train these troubled youth on how to develop and market their ideas. I love it when God has a plan that trumps human understanding and knowledge by coming upon those who have nothing!

Another way we can ride the wave of the harvest is by entering society through creative forms that are already recognized. Just as Daniel was acquainted with Babylonian learning, so we can advance the Kingdom through being relevant in our culture. Jesus wants to touch the hurting in our society. My desire is to bring God's healing power into the places that need it most, like the hospitals, drug rehabs, and abuse shelters. In light of this, as I mentioned, I just received my art therapy certificate from Chapman University so I can bring His creativity into these areas of society that would be closed to me if I came in as a minister or pastor. So far I have gone into Marine bases, hospitals, and anger management programs for youth and helped them process their pain to bring healing. Now I get to apply this favor and touch those in my city where they are hurting.

Sometimes, we just haven't put the threads of our lives together to see the full tapestry of what God is weaving. Let the testimonies in this book and the ideas for Church and marketplace transformation through creativity be the seedbed for your greatest adventure to ride the waves! Remember, you have to get into the water, paddle out, and get up on your board. You have to be willing to do this on a consistent basis, and then you can really enjoy doing tricks and other maneuvers. Find your unique creative factor, and your passion, and decide today how you can begin to move forward toward your destiny!

## *Calling All Creatives!*

I know that many of you reading this book have probably always known that you are creative, and hopefully now you better understand your significance in cultural transformation. I pray you know how priceless you are and how much you are needed in this new wave God is setting up for the harvest. The stigma of negative thinking about your destiny and your creativity has no more power over you! No longer do you have to suffer with fear or dread that you will be poor, depressed, or misunderstood by others or by the Church! I give you permission to happen, explore, and enjoy your life! You are the ones who will write the next *Uncle Tom's Cabin*, paint with excellence like Michelangelo, and write, direct, or act in the next movies about Kingdom core values. There are songs to be written that will awaken monogamy and restore virginity to our society. There are children's books that will portray the true spiritual battle between good and evil, releasing the supernatural power of God to know Him.

This is a time when we are not going to be moving out of reaction, but out of passion for who God is and for how He sees us! This is your time. I appeal to you not to squander your gifts or act like they are not important, but to realize that it is time for you to create and to bring forth God's prophetic words to the Church and to the

world. Have patience with this process, and contend for a greater breakthrough in your life, church, and city. Change is coming and momentum is building for the creatives to take their rightful place in this revival.

> **Change is coming and momentum is building for the creatives to take their rightful place in this revival.**

I want to free you to be the most joyous, happily married, radical, and insane lovers of God the world has ever seen. I invite you to use your creativity for good and righteousness and to display what is on the other side of the wardrobe through fashion, design, art, writing, music, film, dance, and whatever else you love to create! Awaken to His voice beckoning you to create, through the power of the Holy Spirit, things that no one has seen or heard, because you have the mind of Christ! Christ is in you—and you are the hope of glory!

## What If?

Begin to imagine what could happen if we ride the wave into the presence of Creator God. How far could we go? What if we chose to believe in the power of supernatural creativity within us? How would the world be different? How would we handle wars, depression, recession, fear, and other assaults? How would we influence the culture through creative expressions that bring His presence into every home through the airwaves, media, and Internet? What if we could see the power of creativity end child soldiering, abortion, racism, prostitution, and slavery? What if we understood that it wasn't just one person's pursuit, but it was the

whole Body of Christ working together through their unique gifts and calls that would create the song that would awaken the world to God's presence?

Here is a poem, written by Carla Myers, who graduated from the School of Ministry, that illustrates what is possible through supernatural creativity:

What if a doodle destroyed a stronghold
A sketch secured a dream
A paintbrush procured passion
A sculpture could intercede

What if drama released His power
And dance released His love
A poem displayed His beauty
Portals expressed life above

What if knitting knit people together
And cross-stitch crossed race barriers
Or quilting created a covering
And crotchet helped kids feel secure

What if drawing drew people to Jesus
And puppets placed purpose in hearts
Or woodwork would work out division
While *papier-mâché* gave head stars

What if folk songs brought families together
And ballads brought time for a tear
Or musicals made known the issues
And worship songs melted down fear

What if set designs set up a seeker
While script writing set out the way

And filmmaking filled up the empties
And movies gave vision to strays

What if commercials could start minds to thinking
And half-time shows had altar calls
Or rock stars read verses to thousands
And movie stars show God to all

What if millions entered the Kingdom
The harvest brought in by the arts
Souls saved, healed, delivered for Jesus
I say yes, Lord, let me do my part.[1]

# Endnote

1. Carla Myers, vocal performance of "What If," a poem by Carla Myers, *Create*, Compilation by Eric Johnson, compact disc (Redding, CA: Bethel Music, 2004) website: Cre8iveCarla.com.

# Making a Prophetic Art Piece for Small Groups

## Step One

Read through the descriptions of prophetic colors chart so that you are acquainted with the prophetic meaning of each color.

## Step Two

Have people pair up with someone in your group. (Give them 15 minutes to draw.)

Then, you have three choices of what you can focus on in your time, so choose one.

## Leader

You can decide which of these three to choose from at each time. Turn on some soaking instrumental music, and have participants ask the Holy Spirit to guide them as they create.

- Healing: Ask Holy Spirit for a picture of a body part or something for breakthrough for someone. Then draw what you see, using the color meanings as a guide.

- Prophetic: Ask Holy Spirit for a picture, poem, or writing for the person you have been paired up with and begin to draw or write. Use the color meaning as a guide in this appendix.

- Ask for God to release words of knowledge about the person through what God shows you. Begin to draw and write what He shows you.

- Make sure the artist/writer signs the work. We are proud of who we are!

## Step Three

Have each couple share their pieces with each other and talk about what they drew (20 min).

One person shares the drawing and then asks these questions:

- What does this mean to you? (Always ask this.)
- Does this relate to your life?
- Are there things that you see in the picture that I didn't see?

Can I pray for you or prophesy over you in regard to the picture? (Many times people get healed as they touch the picture, so have the person hold it as you describe it. Then ask how the person feels and whether the person can do something that was impossible before or whether there is any improvement.)

## Timer

For those of you who are checking on time, make sure that you have the first person stop after ten minutes and then have the other person share so they both get equal time.

## Leader

After they are done sharing, ask if anyone would like to share about what was drawn for them. This gives people in the whole group a chance to see the power of prophetic art.

Give 20 minutes for people to share.

Sometimes there is a remarkable word or healing. After you are done with this exercise, ask the group if anyone would like to share and if anyone wants to release it for the whole group.

Make sure people know that these pictures can continue to minister and that they should put them up in their houses or keep them in their Bibles.

## Record

Make sure that you record testimonies!

## Other Options

You can also have people sing prophetic songs, write a poem or word for someone, or do a prophetic act where they use their body or props to prophesy over that person. The ways that you can creatively prophesy are endless! Again, you can use art, food, song, dance, prophetic acts, writing, or anything else!

## Homework Assignment

Activate doing prophetic pictures for people at least two to four times this week and share testimonies next week!

I have had groups that make prophetic Valentines and then pass them out together in the neighborhood or stores. You can do this for a holiday—people love it! Your group can focus on making things for people in the group or go out as a group with what you have drawn for others.

# Prophetic Arts Treasure Hunt

1. Each person draws a prophetic picture for someone and then writes down words of knowledge in the spaces allowed for each category below:

• LOCATION (stop sign, store, bench, house, etc.)

_____

_____

_____

• A PERSON'S NAME

_____

_____

_____

_____

- TYPE OF ARTS (drama, art picture, balloon animal, song, prophetic card, word)

- A PERSON'S APPEARANCE (color, clothing, hair, etc.)

- WHAT THE PERSON NEEDS PRAYER FOR (knee, back brace, tumor, ears, etc.)

- THE UNUSUAL (lollypop, dolphins, neon green pinwheel, etc.)

2. Get together in your group, put your clues together, and share about your art pieces. Decide where you will go and choose a beginning location.

3. Start finding out who you need to go to share your picture with.

4. Begin to tell the person that you drew this card for him or her and this is what it means...

   • Approach the person and say something like, "This may seem strange, but I drew this picture for you today, and I'd like to share with you what it means."

   • Show the person your list.

   • Always ask, "What does this mean to you?" so that you get to hear what he or she thinks.

   • Give the the prophetic art piece and share anything that God shows you at this time!

   • Ask if you can pray for the person—praying for healing or for other things.

5. If the person says "no"...

   • Build more rapport (common ground, friendship).

   • Ask the Holy Spirit what He wants to highlight about the person.

   • Give the person some encouraging words (prophesy).

6. Ask again if you can pray.

   • If the person says no again, bless that person and go to the next person!

   • If the person says yes, ask for God's presence to come and command the pain to leave, life to come, etc.

- Ask the person to test it out (i.e., "Do something you couldn't do before we prayed") and give the person your art piece.

7. When the person is healed or touched by God prophetically by the card,

   - Explain what happened.

   - Ask if the person would like to know Jesus personally.

   - Have the person ask Jesus into his or her life!

8. Go to the next appointment if you have more cards to give away. Write down testimonies!!!

# Prophetic Meanings for Colors Chart

- **Amber** – the glory of God, the Father's heavenly care, majesty
- **Black** – the mysteries of God, the secret place, depths, unknown
- **Blue** – heavenly, prophetic, Holy Spirit, grace, revelation, knowledge, the river of God, life-giving flow of the Holy Spirit, refreshing, nourishing
- **Brown** – humanity, earth, harvest, sowing, humility, seed
- **Burgundy/wine** – the new wine, the cup of the new covenant, blessings, rejoicing, the blood of Jesus, the Bride of Christ, richness
- **Gold** – deity, wealth, royalty, refining fire, glory, majesty, power

- **Green** – new beginnings, growth, hope, restoration, happiness, springtime, birth, new life, eternity, abundance

- **Iridescent white** – angelic presence, blessing of God's truth, heavenly realm

- **Lavender** – transparency/vulnerability, fragrance, intercession

- **Orange** – courage, passion, *dunamis* power, fire, harvest, strength

- **Pink** – joy, compassion, healing, friendship, deep place of the heart, romance of God, sweetness, innocence, softness, inner beauty

- **Purple** – royalty, kingship, sonship, inheritance, richness, abundance, infilling of the Holy Spirit

- **Red** – atonement, the blood of Jesus, sacrifice, redemption, love

- **Silver** – refinement, Holy Spirit, freedom to create, strength

- **White** – purity, holiness, righteousness, peace, Bride of Christ

- **Yellow** – courtship with God, intentional pursuit, the glory of God, happiness, joy, friendship, laughter, fun, risk

# Cultivating Supernatural Creativity in Children Guide

## For Children Ages 2-7

Most children at this age are not afraid to be creative, but just have to be equipped as to the supernatural power of their creativity. Here are some ideas that you can utilize to equip them.

**Prophetic:** Share about how God loves to encourage us and then demonstrate by reading First Corinthians 14:3. Share about different ways that we can feel loved—a hug, being nice, or making something for someone.

1. Have them each draw a picture about what God loves about them. After they are done, break into small groups and have them share their pictures, and then bless what they saw in their relationships with God.

2. You can also pair them up with another child and have them draw or create something for another person, showing them how to hear from God. Have them then

share in a small group about what they drew and ask the person what this means to him or her.

**Healing:** Share a Scripture about how Jesus healed people, demonstrating that He heals in creative ways and He heals every type of sickness. Then share about who needs healing that they know and have them creatively go after healing.

1.   They could draw the body part and give the picture to the sick person.

2.   They could dance, declare, sing, or draw on a blanket or piece of cloth that could be given to that person. Go after healing with the children there, too.

## For Children Ages 8-12 (You can use any of the above exercises for this age, too.)

At this point, a child has started school and needs to be taught that whatever he or she creates is good and has power to transform people supernaturally. Release any testimonies about people you have seen being touched either prophetically or through healing from this book. Then, you can have them practice.

**Prophetic:** Explain First Corinthians 14:3 and that whatever we create needs to encourage, strengthen, and comfort others. Use examples to demonstrate what this would look like, and then share that we are not going to use scary, future, or negative images or words when we create. Here are some ideas on what could happen as you equip children in learning how to create with the Holy Spirit.

1.   Have them soak in God's presence and create a piece about what God likes about them and then have each take turns holding up their work and sharing.

2.   Have them prophesy through writing a song, poem, dancing an interpretive dance for someone, or creating an art piece for someone. Have them first ask God what to

create, and then have them pair up and do it for someone in the group.

3. Encourage and bless whatever they create as they are learning to hear from God and use their creativity. Make sure children are not negative about others' works.

**Worship:** You can have children paint during worship, either at children's church or in adult church, as long as there is supervision. Have them ask God for a picture for the people that would be a message from God to them. You will be surprised at how God speaks through children! Have them share the meaning behind their works.

# Recommended Reading List

*Cultivating Kingdom Creativity*
By Theresa Dedmon
(information on manual is in my chapter endnotes)

*The Ultimate Treasure Hunt*
By Kevin Dedmon

*Unlocking Heaven:*
*Keys to Living Naturally Supernatural*
By Kevin Dedmon

*The Risk Factor*
By Kevin and Chad Dedmon

*Dreaming with God*
By Bill Johnson

*Face to Face*
By Bill Johnson

*The Happy Intercessor*
By Beni Johnson

*Finding Divine Inspiration*
By Scott McElroy

*Heavy Rain*
By Kris Vallotton

*Developing a Supernatural Lifestyle*
By Kris Vallotton

*Culture of Honor*
By Danny Silk